THE ISLE OF
SKYE

www.iaincampbellphotography.com

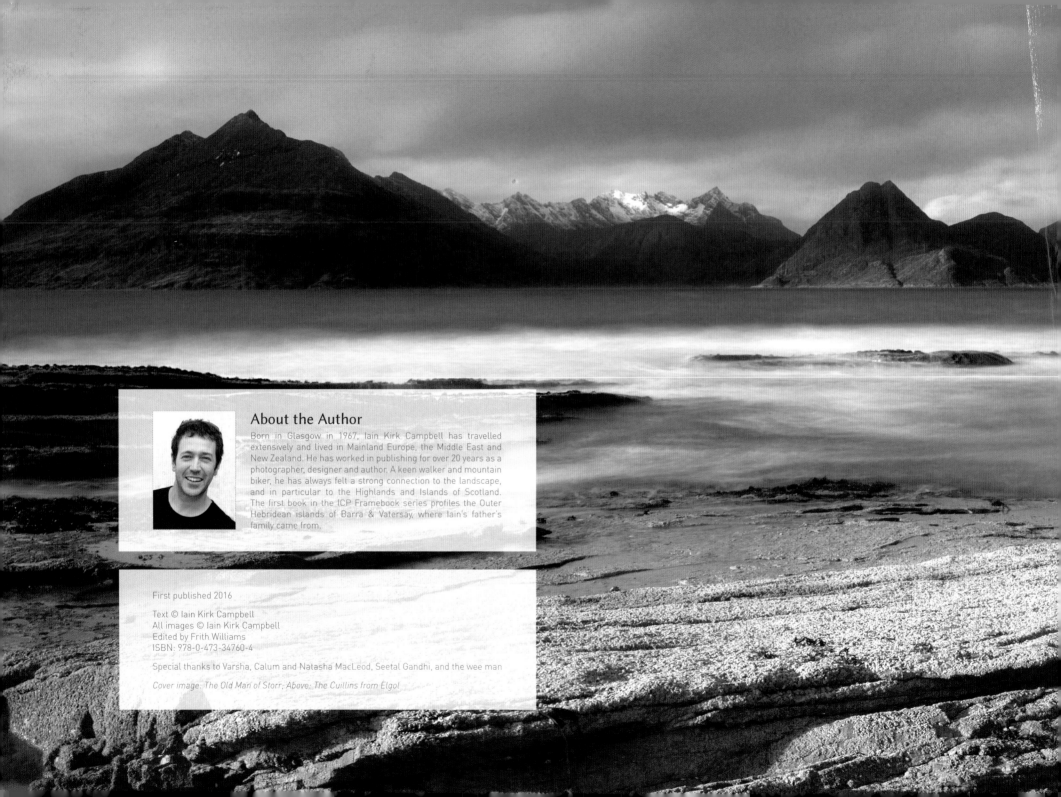

About the Author

Born in Glasgow in 1967, Iain Kirk Campbell has travelled extensively and lived in Mainland Europe, the Middle East and New Zealand. He has worked in publishing for over 20 years as a photographer, designer and author. A keen walker and mountain biker, he has always felt a strong connection to the landscape, and in particular to the Highlands and Islands of Scotland. The first book in the ICP Framebook series profiles the Outer Hebridean islands of Barra & Vatersay, where Iain's father's family came from.

First published 2016

Text © Iain Kirk Campbell
All images © Iain Kirk Campbell
Edited by Frith Williams
ISBN: 978-0-473-34760-4

Special thanks to Varsha, Calum and Natasha MacLeod, Seetal Gandhi, and the wee man

Cover image: The Old Man of Storr; Above: The Cuillins from Elgol

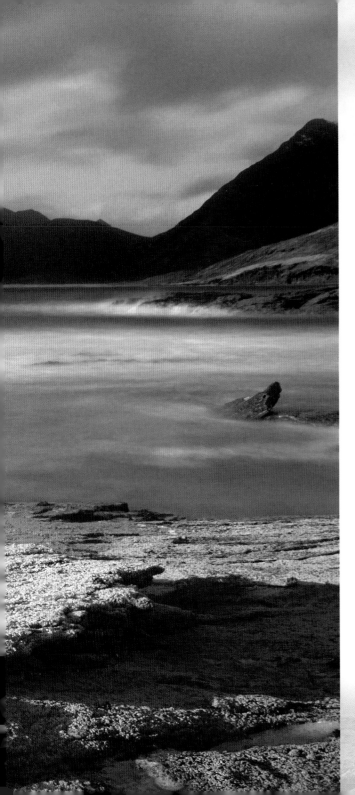

CONTENTS

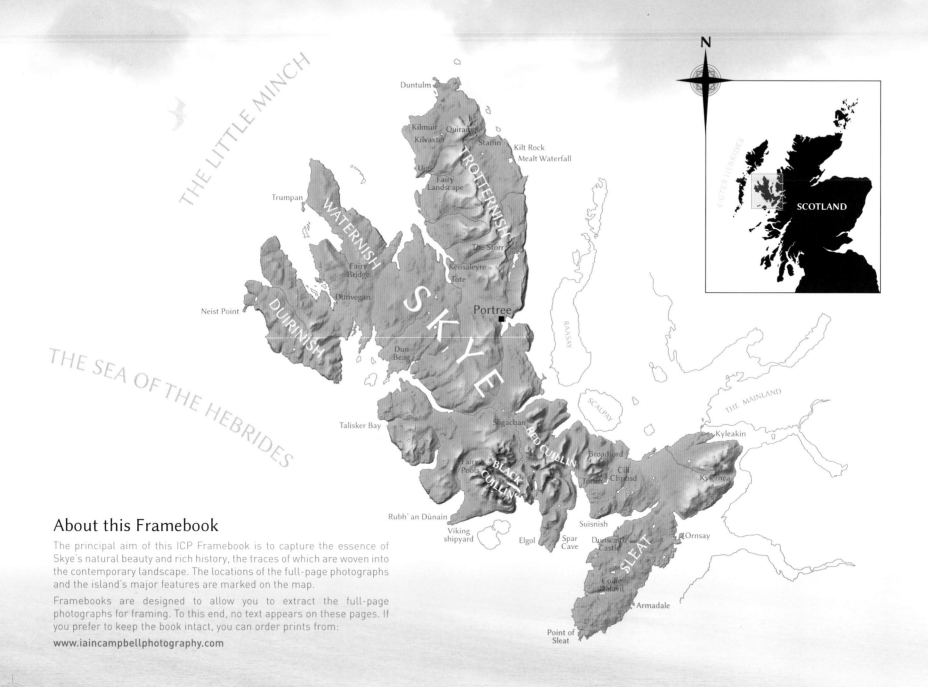

N

THE LITTLE MINCH

Duntulm

Kilmuir
Quiraing
Kilvaxter
Staffin
Uig
Kilt Rock
Mealt Waterfall
Fairy
Landscape

TROTTERNISH

Trumpan

WATERNISH

The Storr

Fairy
Bridge

Kensaleyre
Tote

Dunvegan

S K Y E

Neist Point

DUIRINISH

Portree

RAASAY

THE SEA OF THE HEBRIDES

Dun
Beag

SCALPAY

THE MAINLAND

Talisker Bay

Sligachan

RED CULLIN

Kyleakin

Broadford

Cill
Chriosd

Kylerhea

Fairy
Pools

BLACK
CULLIN

Torrin

Rubh' an Dùnain

Suisnish

Viking
shipyard

Elgol

Spar
Cave

Dunscaith
Castle

Ornsay

SLEAT

Coille
Dalavil

Armadale

Point of
Sleat

SCOTLAND

OUTER HEBRIDES

About this Framebook

The principal aim of this ICP Framebook is to capture the essence of Skye's natural beauty and rich history, the traces of which are woven into the contemporary landscape. The locations of the full-page photographs and the island's major features are marked on the map.

Framebooks are designed to allow you to extract the full-page photographs for framing. To this end, no text appears on these pages. If you prefer to keep the book intact, you can order prints from:

www.iaincampbellphotography.com

Right: Talisker Bay

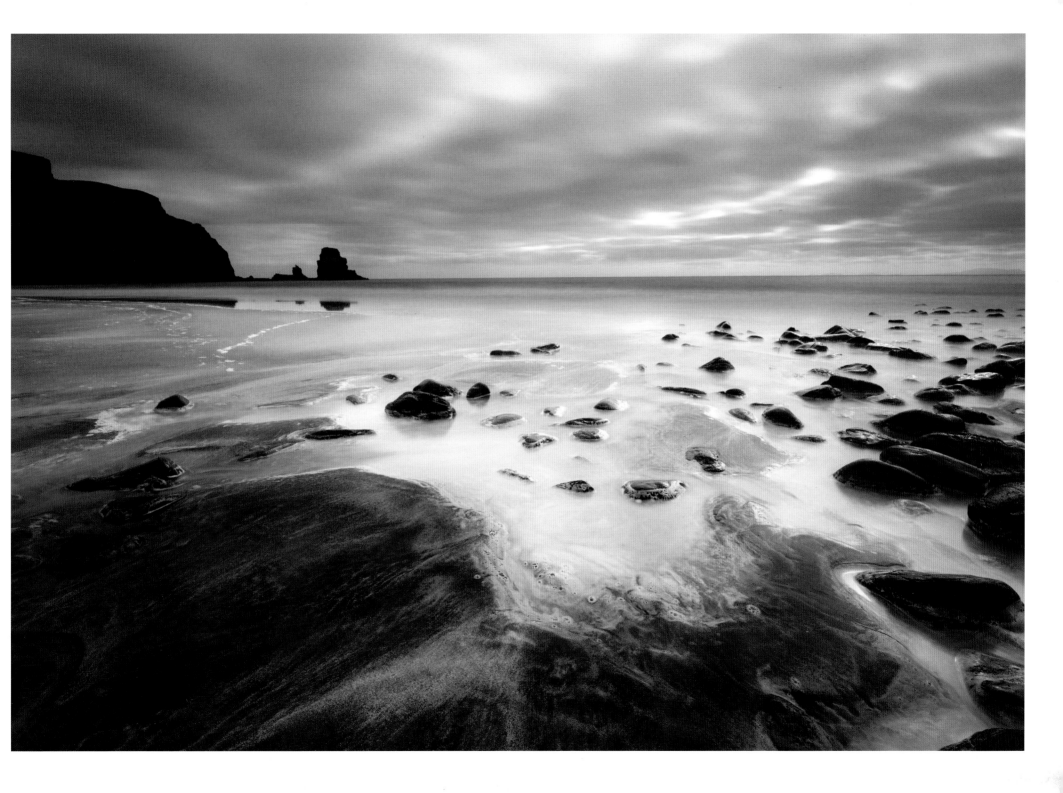

INTRODUCTION

Skye is the largest and northernmost major island of the Inner Hebrides. Wing-shaped and deeply indented by sea lochs, it fans out from the western coast of the Scottish mainland towards the outer islands of the Hebridean archipelago.

Within its shores can be found the Highlands of popular imagination. Giant escarpments, needle-like pinnacles and mist-shrouded mountains tower over heather-clad glens, shimmering lochs and wild moors. The coastline features stacks, arches, caves, sweeping bays and great sea cliffs. Waterfalls plunge into steely blue seas, and powerful tidal streams surge around the sea-lochs, menacing many an unwary mariner. Approximately 80 kilometres long and 40 kilometres across at its widest point, Skye has more than 530 kilometres of dramatic shoreline.

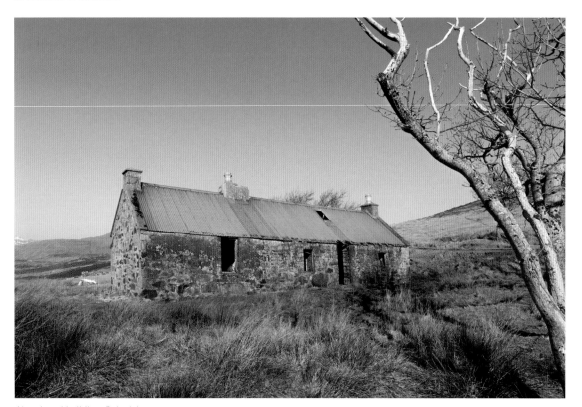

Abandoned building, Suisnish

The captivating scenery is testament to a turbulent past. Geologically complex, the island has been shaken by earthquakes, blasted by volcanoes, swamped by lava, buried under ice and torn asunder by massive landslips. Over the aeons, its peaks and troughs have been further worked on by shattering frosts, shearing glaciers and torrents of water.

The earliest evidence of people on Skye dates back to around 6,500BCE. These small groups of hunter-gatherers did not begin to settle until the dawn of agriculture from around 6,000-4,000 years ago.

Today the island is peppered with archaeological sites, having escaped the unbridled development seen in much of the British Isles. Neolithic standing stones, Iron Age forts, ruined castles and abandoned villages are a vivid reminder of Skye's ancient, and sometimes brutal, past.

Right: Neist Point, Duirinish
Overleaf: Loch Cill Chriosd and the Red Cuillin

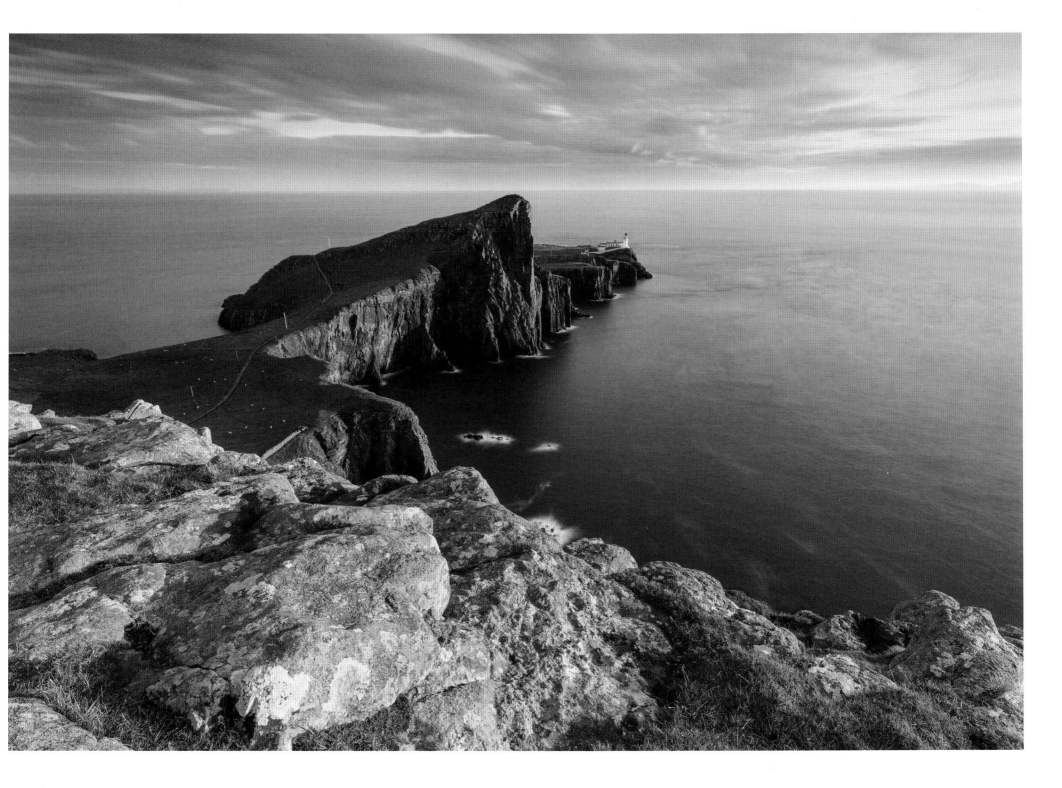

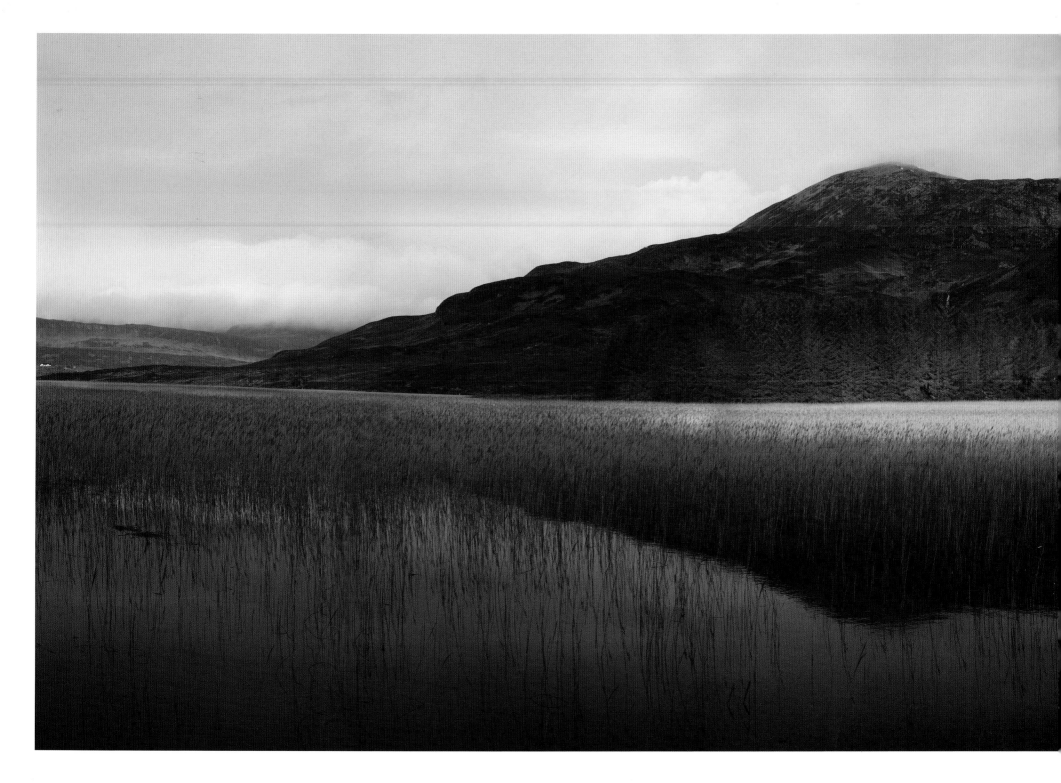

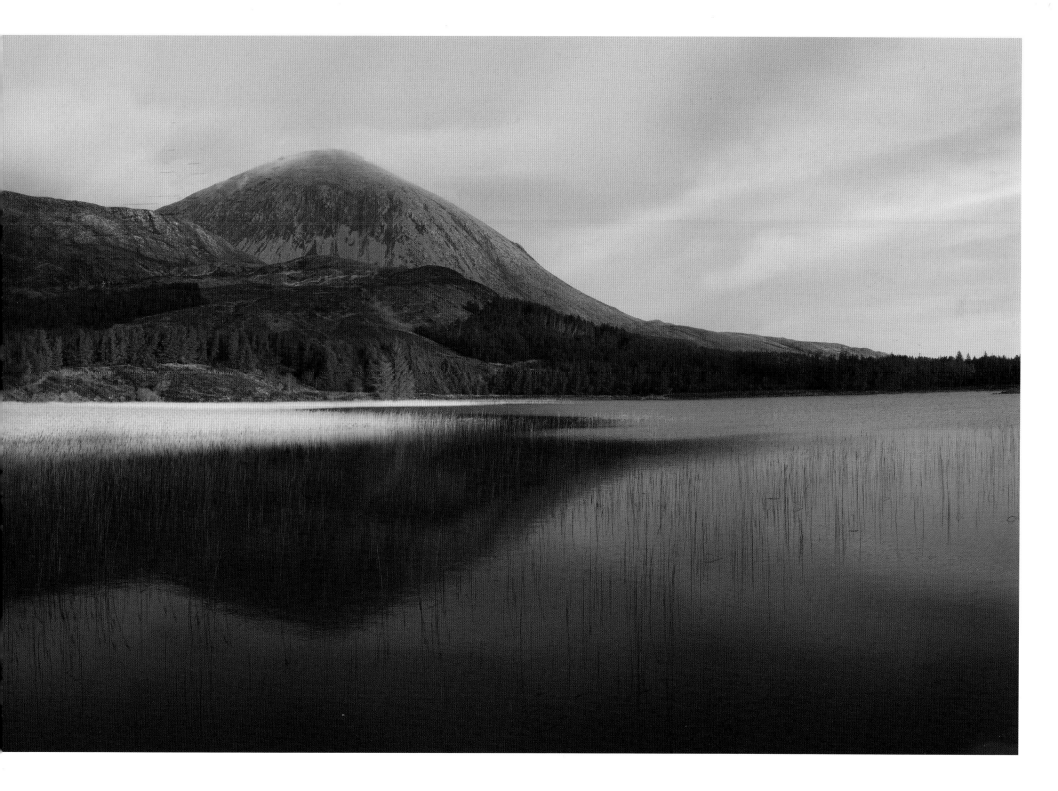

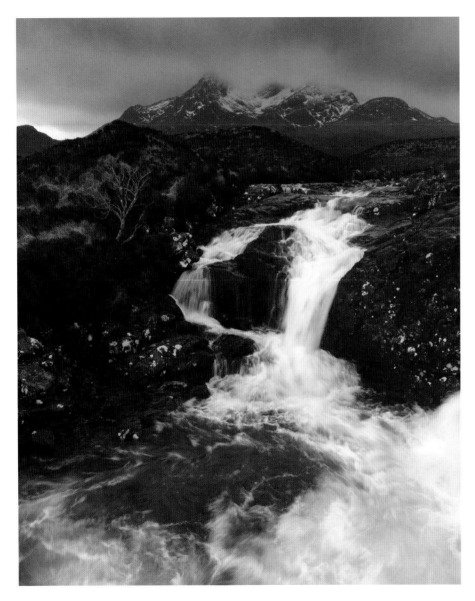

Skye is known in Gaelic as Eilean a' Cheo – Island of Mist. Its northern climate is tempered by the Gulf Stream, a current of warm water that sweeps across the Atlantic from the Gulf of Mexico. Vigorous weather systems funnel in from the west, animating the skies. Sun rays break through gaps in the cloud to throw search-beams racing across the hillsides. Squalls career over lochs, whipping the water up into spectral, whirling dervishes.

If you explore the island's summits, mists can suddenly reduce your world to a few metres of precarious ledge. Just as quickly, they can clear like cast-off spells to reveal vast ocean panoramas and the hazy profiles of the outer isles. Skye's climate, while changeable and undeniably challenging, is also integral to its rugged character and beguiling appeal.

Over the millennia, Skye has been settled on and fought over by Picts, Gaels, Vikings and of course Scottish clans – the two most powerful being the MacLeods and their once bitter rivals, the MacDonalds. Blood feuds, heroism, ruthless power struggles and shameful injustices have all played their part in the island's tangled past.

Sharing the stage have been the characters of myth and legend. In the seas encircling Skye dwell alluring phantoms. Populating the mountain tracks, glens and lochs are fairies, the ghosts of restless souls, shape-shifting seal people and water-dwelling horse spirits.

When you visit Skye today, you can be assured of a warm Highland welcome. Since the construction of the bridge over Loch Alsh to the mainland in 1995, Skye has become more popular than ever, but has managed to retain its island identity. Its sense of community continues to mark it as a place apart.

Allt Dearg Mor waterfall, Glen Sligachan

Right: Elgol foreshore, looking towards the Cuillin ranges

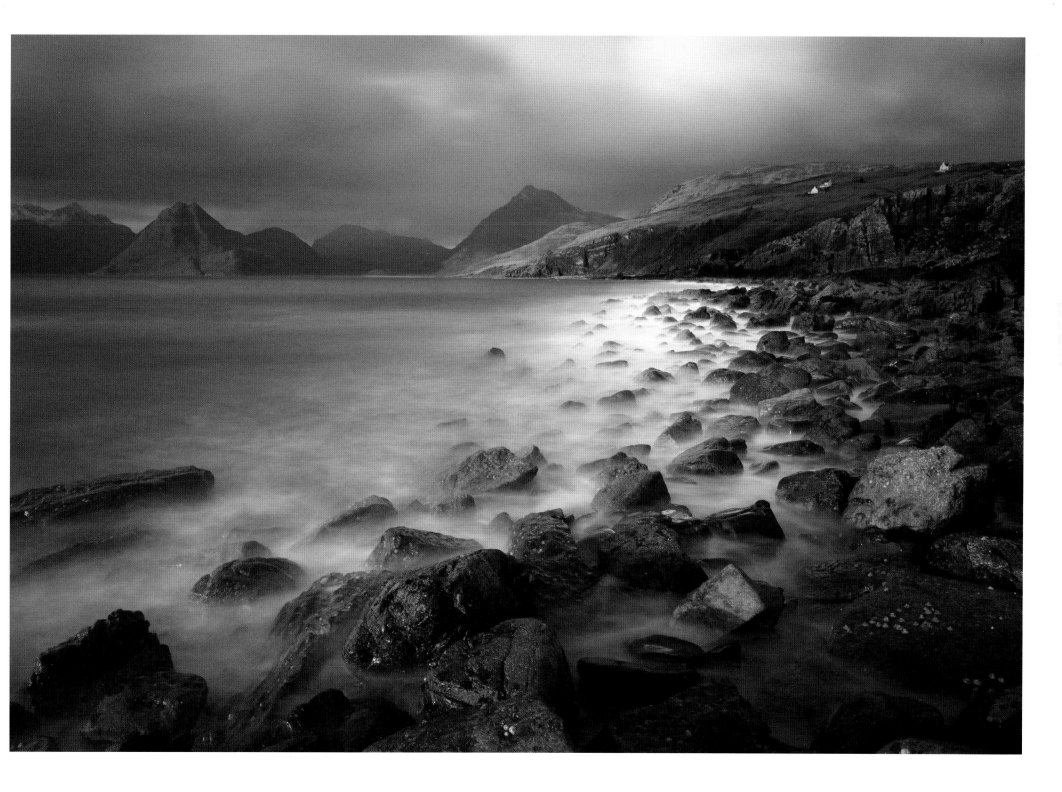

WRITTEN IN STONE

Skye's landscape is layered with the traces of ancient lives. Some 165 million years ago, long before the Cuillin ranges had even formed, a large predatory dinosaur walked through a tidal swamp in the area we now call Staffin Bay. We know this because, remarkably, the animal's footprints survived, and its passage is still visible in the sandstone at An Corran. This and other extraordinary discoveries dating from the Jurassic Period have established the island as a palaeontological site of world importance. During the Jurassic Period, the land that would become the Isle of Skye bore little resemblance to the place we know today. It was at a latitude similar to that of modern Greece, was still attached to what is now North America, and enjoyed a subtropical climate.

The First People

The earliest traces of human activity on Skye are middens (shell dumps) at Staffin Bay. These mounds date back 8,500 years to the Mesolithic Period, or Middle Stone Age, and are among the oldest archaeological sites in Scotland. The Mesolithic hunter-gatherers who left them are also believed to have cleared woodland to attract grazing animals for hunting. Only from around 6,000-4,000 years ago, during the Neolithic Period, or New Stone Age, did people adopt agriculture and begin to create durable monuments, some of which have survived to this day.

Standing stones and chambered cairns (burial monuments) are testament to the changing relationship of these early farmers to their environment. Although their nomadic ancestors had practised a kind of proto-agriculture when clearing forest, these Neolithic agriculturists truly pioneered a radically different way of living. With their settled lifestyle came the need to cooperate with others in communities. Pooling their resources, they were able to create the island's first substantial human structures.

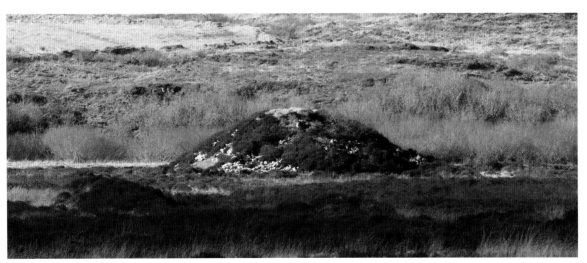

Carn Liath, Kensaleyre

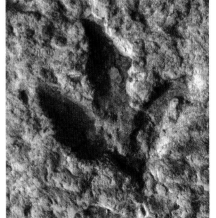

Dinosaur footprint, Staffin Bay

Right: Staffin Bay

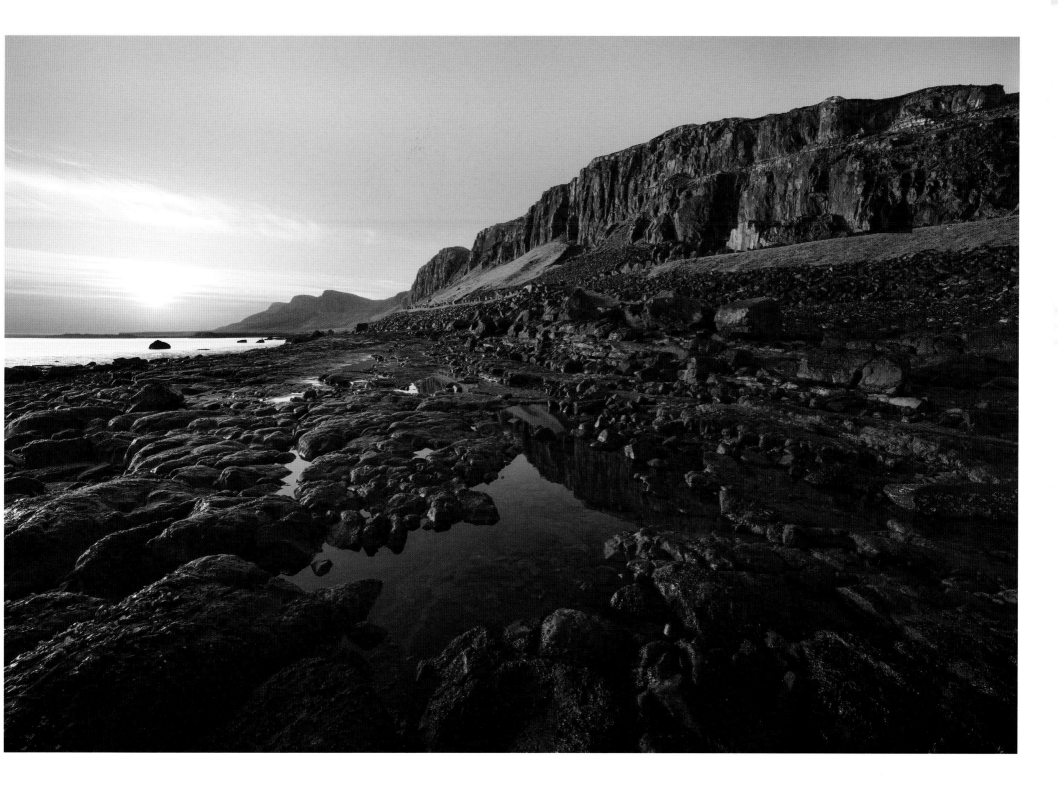

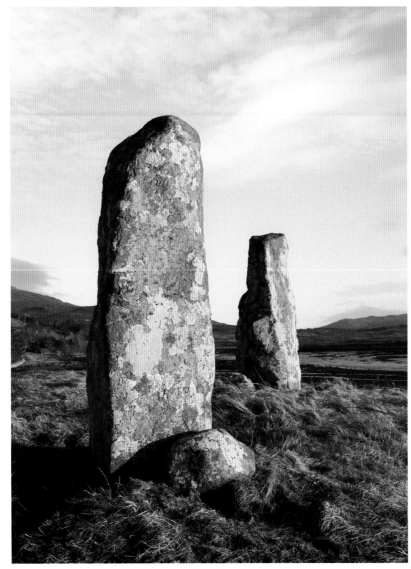

Sornaichean Coir' Fhinn standing stones, Kensaleyre

Chambered cairns, such as the 4-metre-high Carn Liath at Kensaleyre, with its stone coffin, were clearly used for funeral rites and honouring deceased kin. Standing stones present more of a mystery. Competing theories propose that they were used as observatories, territory markers, calendars, places of ritual, and monuments to individuals. Common throughout North-Western Europe, they were arranged in various ways – as single monoliths, in lines, in horseshoes, in circles – and it is possible that their purposes were as varied as their forms.

Sometimes local legend supplies a more intriguing explanation, as with the twin sentinels known as Sornaichean Coir' Fhinn on the outskirts of Kensaleyre. It is said they were placed there by the giant Fingal and used to suspend a huge cooking pot containing an entire deer.

Across Skye is evidence of architecture that characterised the Bronze and Iron Ages (from around 2000BCE to the earlier centuries CE). Examples include chambered cairns, subterranean stone-lined structures called souterrains, forts (known locally as duns), and circular drystone brochs (towers).

On the Rubh' an Dunain peninsula, south-west of the Black Cuillin, are the remains of a Bronze Age chambered cairn. When it was first excavated in 1932, the entrance was left open, and at some stage the roof was removed, allowing those not easily spooked to access its inner chamber.

Close to Struan on the west coast is Dun Beag, Skye's best preserved Iron Age broch. Brochs are sophisticated, circular, drystone towers that represent the apex of Iron Age Scottish architecture. Thought to have ranged from 5 to 15 metres in height, they had inner and outer walls that converged as they rose. Lintel stones bridged the gaps between the walls to form staircases. Not all brochs were positioned defensively, and their exact purpose is unclear. We can at least be sure that they served as potent symbols of status and authority.

Right: Ruins of Dun Beag Iron Age broch (tower)

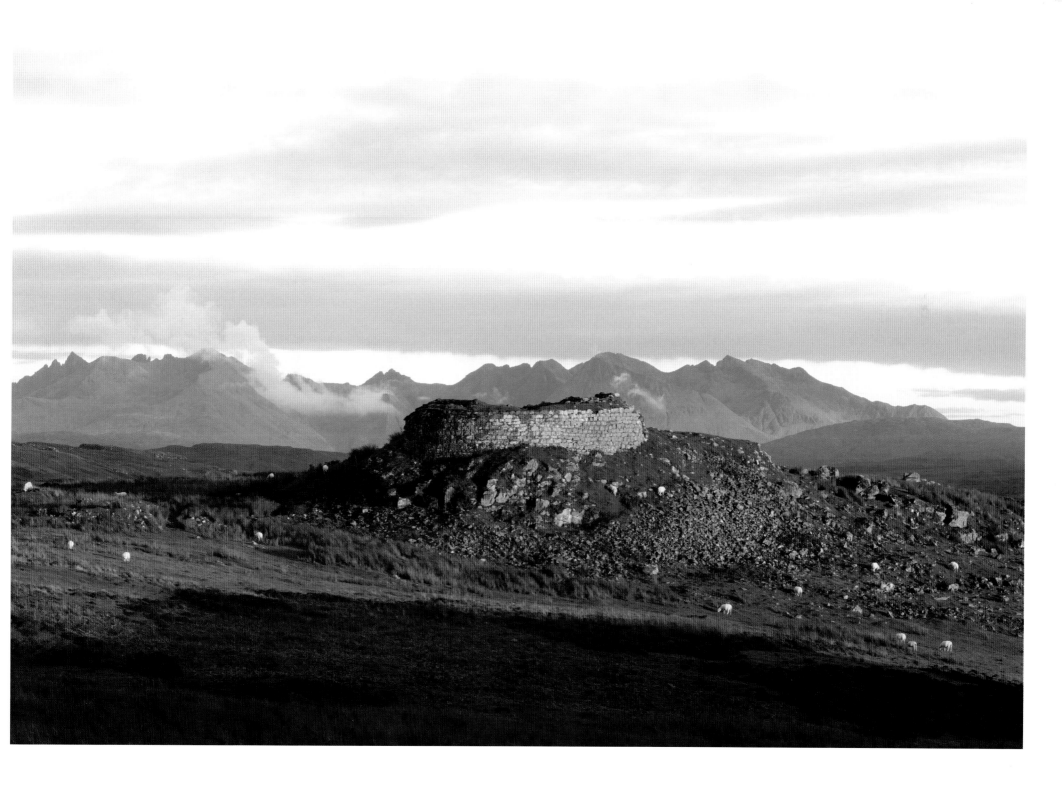

Clach Ard Pictish Stone

Enigmatic artefacts like this Pictish stone are relatively rare in western Scotland. The stone was being used as a doorjamb in a local cottage before it was identified and resited to the roadside in Tote, roughly 8 kilometres north-west of Portree. Dating from the 600s, it is engraved with a crescent and V-rod, and a double disc and Z-rod. Mirror and comb symbols once adorned its base, but they are now obscured. We can only speculate on the meaning of these Pictish symbols, but they may represent individuals and family groups.

At the north-western end of the Trotternish peninsula is the Kilvaxter souterrain, or underground passageway – one of at least 20 souterrains on Skye. Many are quite remote, and some have been deliberately concealed. Kilvaxter's, however, is well marked and just metres from the main road. These subterranean structures, formed of a shallow s-shaped passage with a single chamber, are now generally believed to have been used as winter food stores. The remains of an Iron Age farm near Kilvaxter support this belief.

One of the island's most extraordinary archaeological sites is the Viking shipyard at Loch na h-Airde, close to the Bronze Age chambered cairn on the Rubh' an Dunain peninsula. This shipyard, which resembles a piece of contemporary land art, includes the remnants of a stone-built quay and boat timbers dating back to the 1100s. A man-made canal, complete with a blocking system to control the water level, connects the loch to the sea. It is thought that the loch was used as a safe haven for Norsemen to overwinter and maintain their fleets – crucial activities for anyone wanting to control the Hebrides in medieval times.

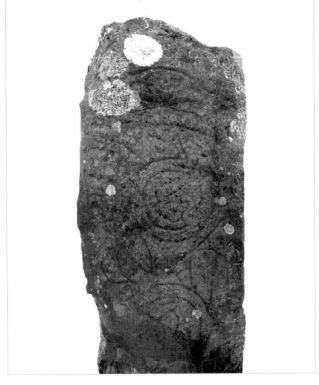

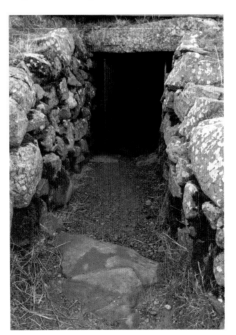

Kilvaxter souterrain entrance

Inner chamber of cairn, Rubh' an Dùnain

Right: Remains of Viking shipyard, Loch na h-Airde

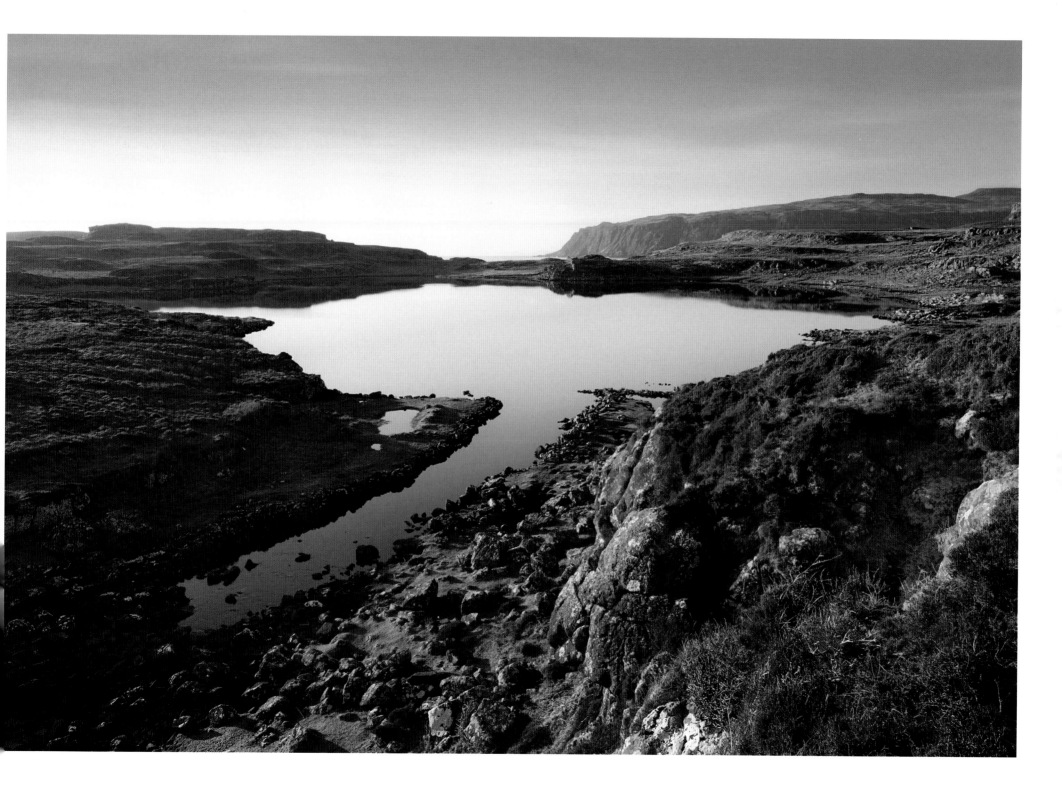

THE CUILLINS

The Black Cuillin

The iconic Black Cuillin are widely regarded as the finest mountains in Britain. The spectacular range rises sharply out of the waters of Loch Scavaig in the south, arcing north to form a 13-kilometre-long horseshoe of precarious, frost-shattered peaks. The chain is home to Skye's 12 Munros (Scottish mountains over 3,000 feet, or 914 metres). It is strung together by a series of serrated ridgelines that fall away to steep scree slopes and gullies.

Local legend has it that the Black Cuillin were created by the great heat of the sun god, who burned the land until giant black blisters swelled up from the ground. Were this sun god a subterranean deity, then modern geology might almost agree with this account. Volcanism has played a pivotal role in forming Skye, and the Black Cuillin were indeed born from fire and fury of biblical proportions. The mountains we see today are but the eroded remnants of a gigantic magma chamber and were formed around 65 million years ago. Repeated glaciation has also played a major part, sculpting steep-sided corries holding high lochans, as well as gouging out Loch Coruisk, around which the range extends.

The name Cuillin is thought to have derived from the Viking 'kjölen', meaning keel-shaped. There are a number of alternative theories, chiefly that the name originates from Cúchulainn, a legendary Gaelic hero.

The mountains are composed mainly of coarse, dark-coloured gabbro (hence the name Black Cuillin) and basalt. The tallest peak is the 992-metre-high Sgùrr Alasdair, named after Sheriff Alexander Nicolson, who in 1873 became the first to reach its summit.

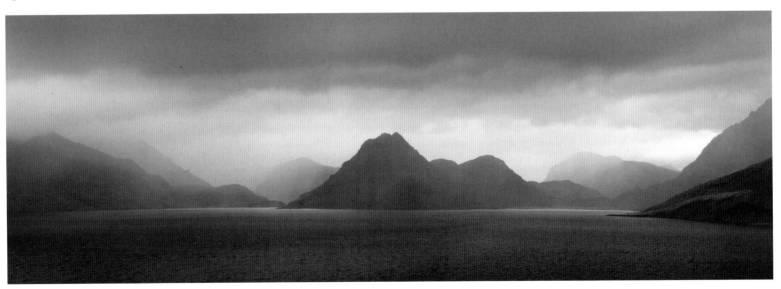

Rain shrouds the Cuillins

Right: Allt na Dunaiche and Bla Bheinn

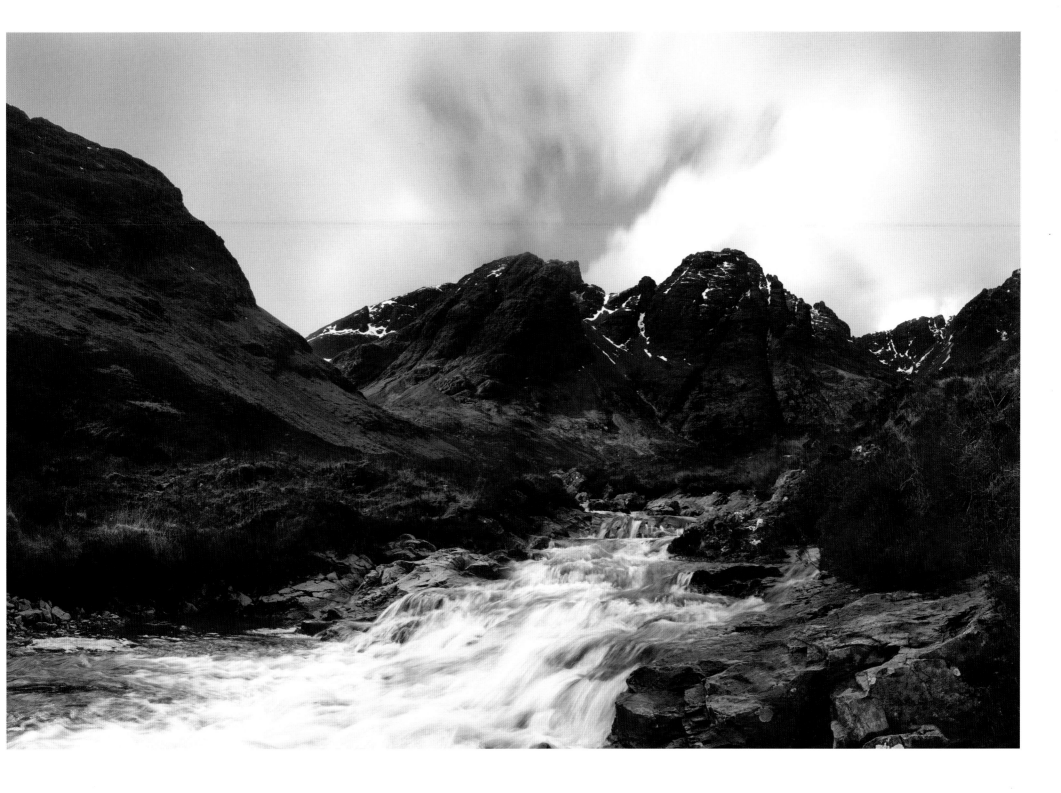

In 1601, the last serious battle between the Skye branches of the clans MacDonald and MacLeod took place on the lower slopes of Bruach na Frìthe, at the northern end of the range. Dubbed 'The War of the One-eyed Woman', it was sparked when the MacDonalds gravely insulted Lady Margaret MacLeod, the one-eyed sister of the MacLeod lord. The ensuing feud led to a year of violence culminating in the battle, which the MacLeods lost.

The Black Cuillin are a Mecca for climbers seeking what some consider to be the only true alpine environment in the British Isles. The many slabs and towering cliff faces, with their high-friction surface of gabbro, attract large numbers of rock climbers keen to test their mettle. Traversing the mountains in both summer and winter has become popular. The range offers some of the sharpest peaks and most challenging mountaineering in the country. Sgùrr Dearg's summit, a fin of basalt known as the Inaccessible Pinnacle, is the most technically challenging and prestigious of Scotland's Munros. These awe-inspiring mountains demand respect and can prove fatal to those who underestimate them.

The superstitious should also take heed, lest they run into the ghost of the outlaw MacRaing. He is believed to have robbed and then murdered a girl at Tobar a' Chinn – Well of Heads. When his outraged son threatened to disclose his crimes, MacRaing murdered him too, placing his head in the well. MacRaing's restless soul is said to haunt the black range.

The Red Cuillin

The Red Cuillin are sometimes referred to as the Red Hills, and are known in Gaelic as Na Beanntan Dearga. The range stands to the east of its brooding neighbour, the Black Cuillin. Both are the products of ancient volcanic magma chambers, but they differ greatly in character. The Red Cuillin are slightly younger and are composed mainly of granite, as opposed to the basalt and dark gabbro of the Black Cuillin. The paler granite erodes to form smoother, rounder surfaces and can appear to have a reddish tinge, particularly when the sun is low in the sky. Patches of vegetation manage to cling on all the way up to the summits, whereas the upper regions of the Black Cuillin are bare.

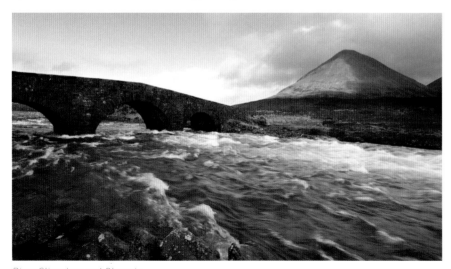

River Sligachan and Glamaig

Glamaig, at the northern end of the range, is the highest peak of the Red Cuillin. At 775 metres, it is one of only two Corbetts on Skye, the other being Garbh Bheinn to the south. Corbetts are Scottish hills that reach heights of between 2,500 and 3,000 feet (762 and 914 metres), with a prominence of at least 500 feet. The name Glamaig is of Norse origin and translates as gorge mountain, though it is more popularly understood as greedy woman – perhaps in reference to the mountain's spreading girth.

The Red Cuillin are less formidable than the Black Cuillin to climb, but they can still pose a challenge. The most fabled ascent of Glamaig was made in 1889 by a Gurkha called Harkabir Tharpa. The estate owner had heard tales of Harkabir making the round trip from Sligachan to the summit and back in an hour and a quarter, which he simply could not believe. To settle the matter, Harkabir agreed to repeat the feat. Allegedly barefoot, he took 20 minutes off his previous time, completing the run in 55 minutes.

Right: Patches of vegetation cling to the slopes of the Red Cuillin

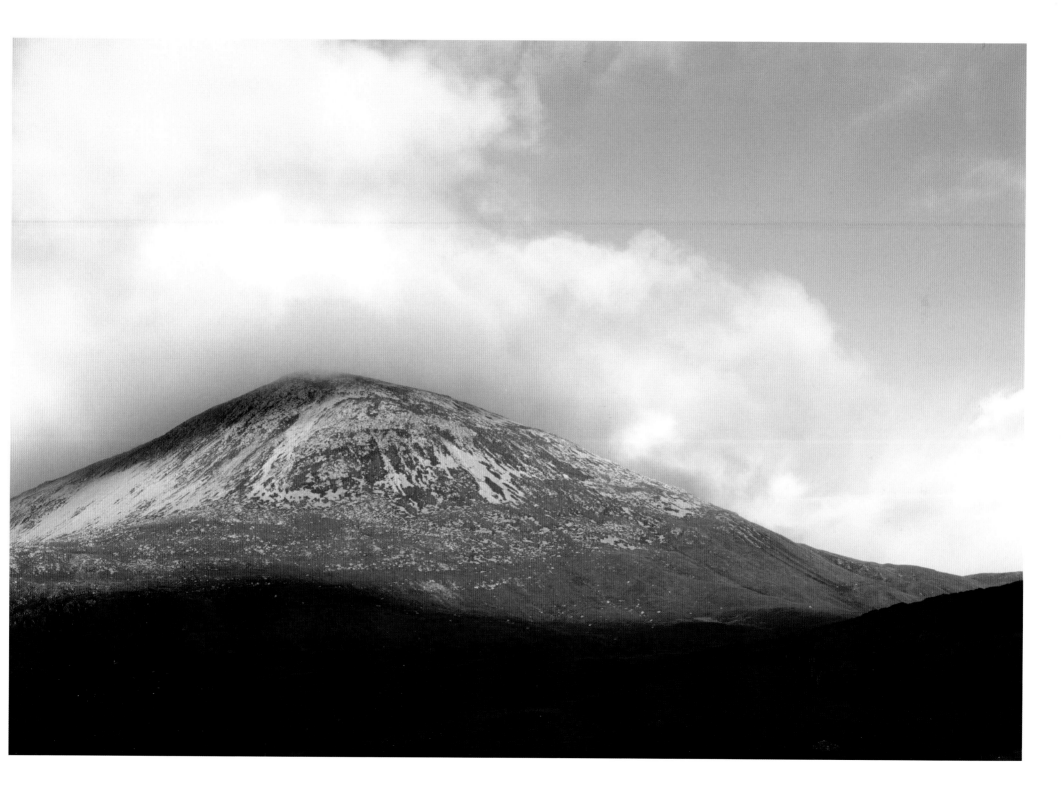

TROTTERNISH

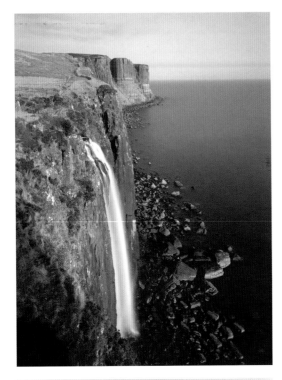

Skye's largest peninsula reaches out from Portree to the island's northernmost point at Rubha Hunish. Roughly 30 kilometres long, and measuring 14 kilometres at its widest point, Trotternish packs in far more than its fair share of natural beauty. Witnessing this land of giants materialise from the predawn is well worth the early rising – the golden light reveals dramatic scarps, moorlands and lochs stretching to the horizon.

The imposing Trotternish Ridge rises steadily from the west until it falls away in a series of massive landslips to the eastern seaboard. If you hike the 30-kilometre ridgeline on a calm and clear day, the going is relatively easy over close-cropped sward, and sweeping sea views reward your effort.

Towards the southern end of the peninsula is its highest peak, the 719-metre Storr. Standing below the Storr's towering cliff face is the iconic Old Man of Storr, a 50-metre-high dagger of basalt. Unlike the gabbro of the Black Cuillin to the south, this brittle, slippery rock is not favoured by climbers. In fact, the daunting Old Man remained unconquered until Don Whillans and James Barber managed to scale it in 1955.

Towards the northern end of the ridge, overlooking Staffin Bay, is the Quiraing, a series of five successive slips extending over 2 kilometres to the coast. To English speakers, 'Quiraing' – a Norse word meaning 'round fold' – is suitably odd sounding. The jumbled features that make up the landscape have evoked names such as 'The Prison', 'The Needle' and 'The Table' – an incongruous flat-topped stump of turf-covered rock where the locals used to play shinty.

Many colourful legends recount the origins of this strange land. One says that the Old Man of Storr is the thumb of a buried giant; another that it was sculpted by a brownie – a magical being similar to a hobgoblin. Geologists offer a different explanation – that these unlikely configurations are children of the same volcanic events that formed the Cuillins. At least 24 great lava flows have spilled over the original sedimentary rock. That rock, dating from the Jurassic Period, has collapsed under the enormous weight, tilting the land westward and exposing the steep scarps of the ridge to the east. Along the eastern coast, sections of cliff like the 70-metre-high Kilt Rock, reveal yet more volcanism. There, lava flows have squeezed up into the sedimentary rock but not made it to the surface. Cooling very slowly, they have formed distinctive hexagonal pillars. At the foot of the cliffs, sedimentary mudstones, sandstones and fossil-rich limestones splay out to form a skirt down to the foreshore.

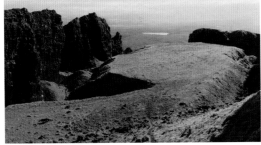

Top: Mealt Falls and Kilt Rock; Bottom: The Table

Right: Trotternish Ridge
Overleaf: The Old Man of Storr after a winter hail storm

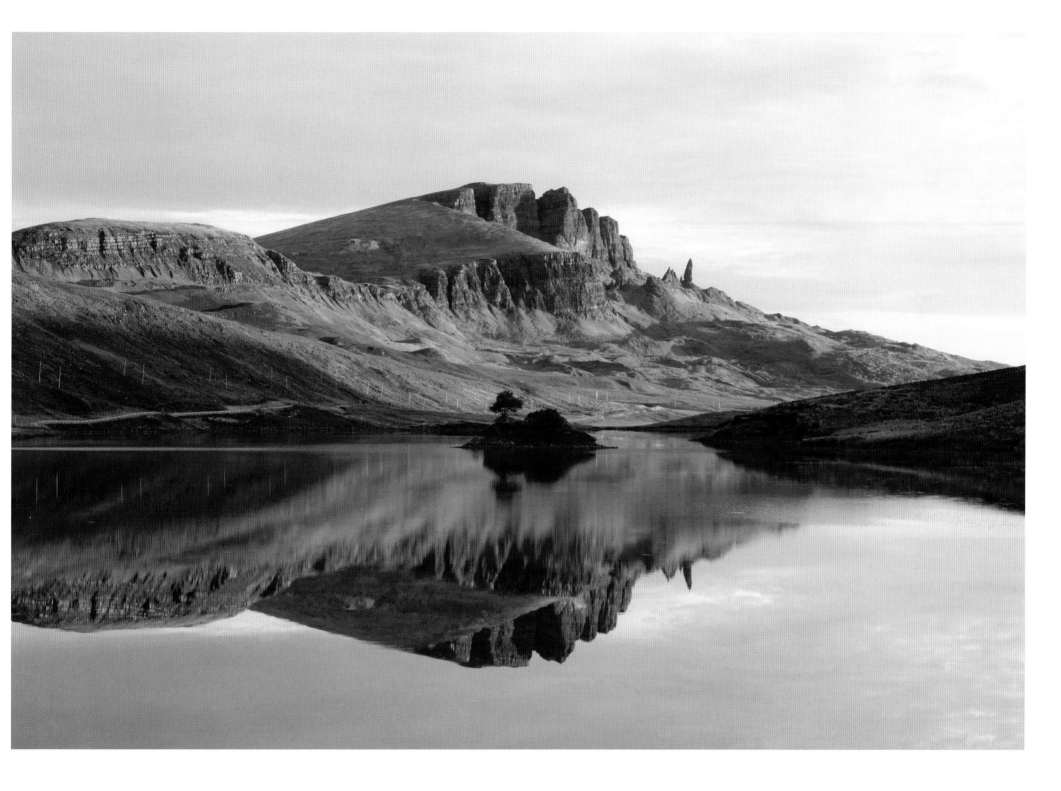

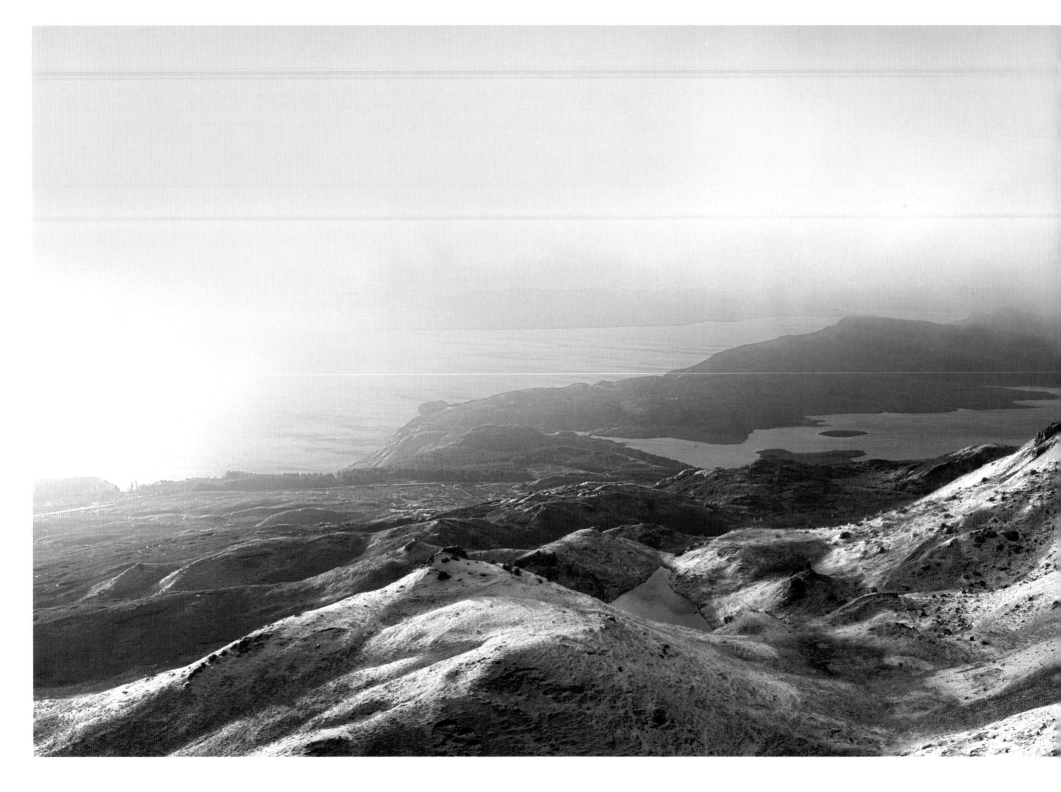

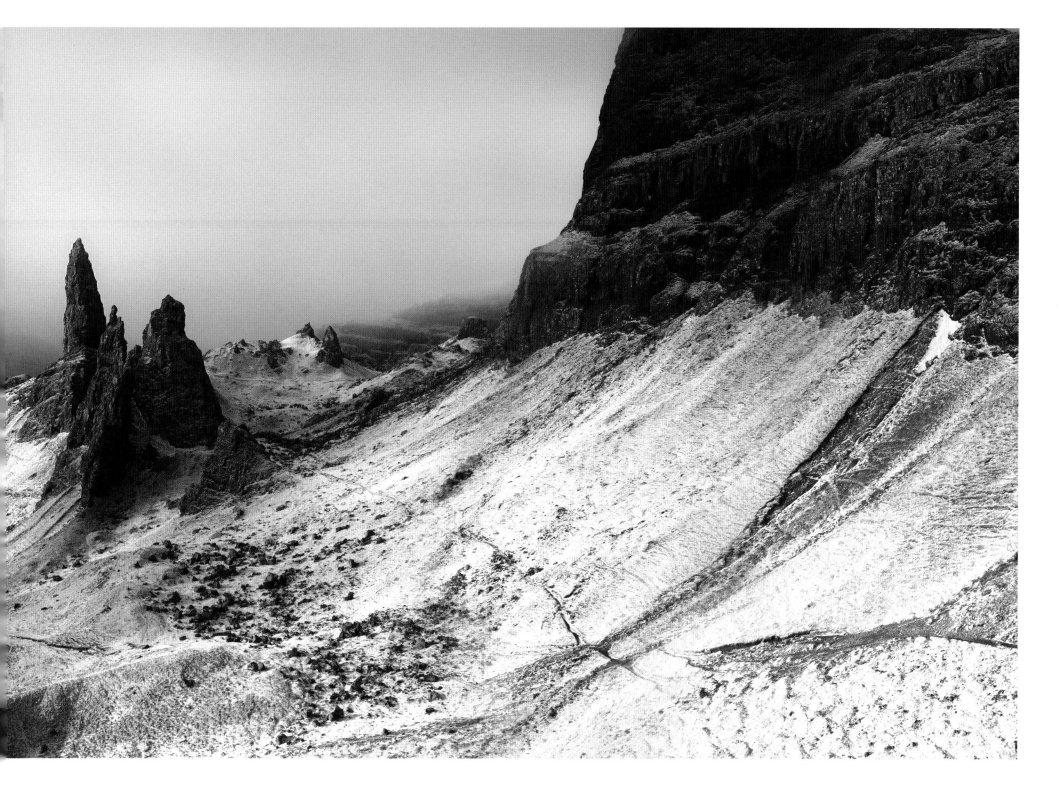

Clans

Historically, the two dominant clans on Skye were the MacLeods and the MacDonalds. Septs of these two major players and smaller island clans included the MacKinnons, Nicolsons, MacCrimmons, MacAskills, Beatons, MacQueens, Martins and MacInneses. A sept is a branch of a larger clan that retains its name and some degree of independence.

Strategic positions on the island are marked by the remains of clan strongholds, often built on top of Iron Age duns (forts). Over the years, many of these fortresses have changed hands and gathered legends. A typical example is the much diminished ruin of Castle Maol, overlooking the Kyle Akin strait, which separates Skye from the mainland. This castle was once the seat of the clan MacKinnon. The fourth chief and his Norse wife, known as 'Saucy Mary', are said to have run a heavy chain across the strait, extracting tolls from passing vessels.

The powerful MacLeod and MacDonald clans were once allies, but began feuding when the latter was forced to forfeit the Lordship of the Isles to the Scottish Crown in 1493. The most infamous episode began in 1577, when the MacLeods massacred nearly 400 MacDonalds in a cave on the Isle of Eigg. In revenge, a party of MacDonalds from Uist slaughtered the Sunday morning congregation in Trumpan Church. Only one badly wounded girl escaped, surviving long enough to raise the alarm. The MacLeods launched a counter-attack and, in what became known as the Battle of the Spoiling of the Dyke, virtually wiped out the raiders. Denied a proper burial, their corpses were unceremoniously tossed into a nearby dyke.

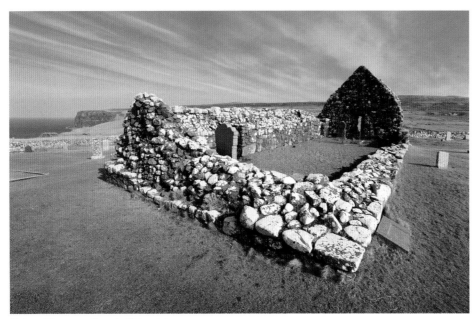

Ruins of Trumpan Church, Waternish

Clan MacLeod

Dunvegan is the oldest continuously inhabited castle in Scotland. Seat of the MacLeods for eight centuries, it bears testament to the clan's motto 'Hold fast'. The castle is built on a rocky outcrop on the eastern shore of Loch Dunvegan, a superb defensive position which, until the mid 1700s, was only accessible via a sea gate on its north-west side.

The castle today is the result of at least 10 different periods of construction, beginning in the 1200s with a defensive curtain wall, which probably housed wooden buildings with thatched roofs. Fragments of this wall have survived, and have been incorporated into the current structure. Over the centuries, clan chiefs have developed the site. In the 1500s, the free-standing 'Fairy Tower' was integrated into the structure. In the 1840s, Norman MacLeod, the 25th chief, commissioned the Victorian harmonising of the castle's disparate elements. The same chief is remembered for his efforts to alleviate the suffering of his

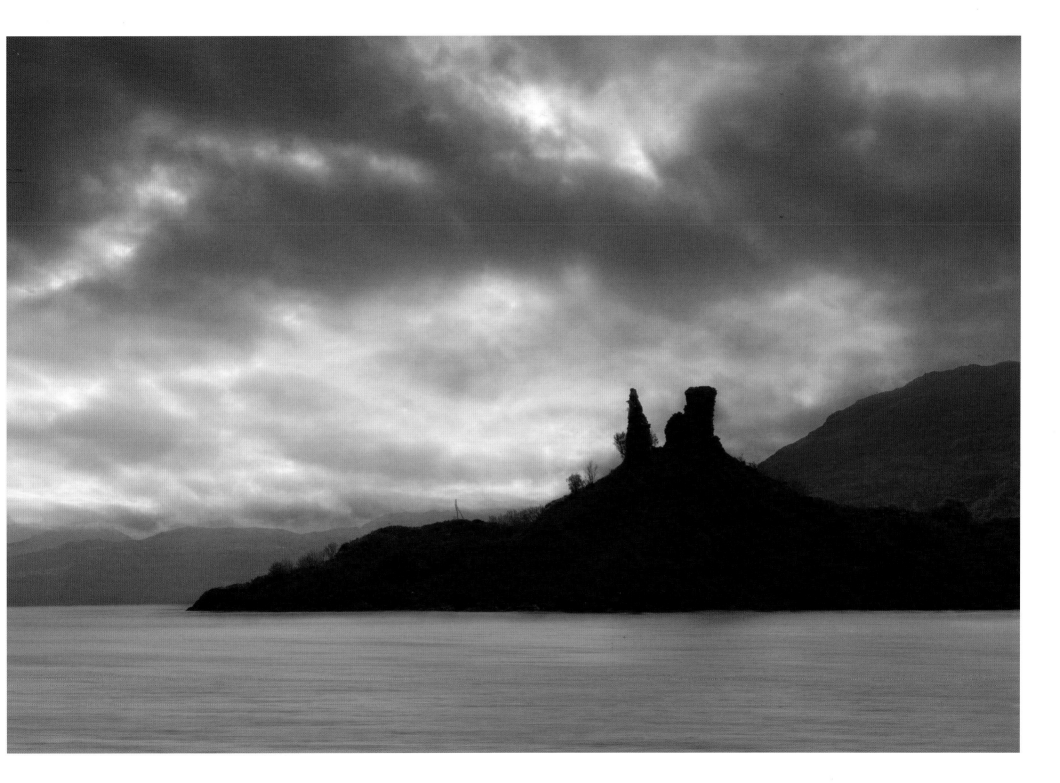

tenants during the mid-century potato famine. His struggle to sustain 8,000 people proved financially ruinous, and he was forced to leave the castle in search of employment, which he duly found in the Victoria and Albert Museum in London. The castle fell into the hands of trustees and did not become the residence of the clan chief again until 1929.

The origins of both the clan MacLeod and Dunvegan Castle can be traced to Leod Olafson, son of Olaf the Black, the Norse King of the Isle of Man. Born around 1200CE, Olaf married the heiress of the Macarailts, the then Viking rulers of Skye. During Leod's time the curtain wall was raised, though some fortification probably existed already, built by Norsemen and earlier Iron Age settlers.

For much of the Middle Ages, the Norse held sway over extensive areas of the Highlands and Islands of Scotland, but in the 1200s, that was to change. Leod had two sons, Tormod and Torquil. Torquil became the progenitor of the MacLeods of Lewis, and his older brother Tormod became the first chief of the Dunvegan MacLeods. In 1263, during Tormod's tenure as chief, Alexander III of Scotland defeated the Norse King Haakon IV at the Battle of Largs. Haakon died shortly afterwards, prompting many prominent Norse dynasties, including Leod's, to swiftly and shrewdly morph into Gaelic-speaking clans. Successive chiefs have left their mark on Dunvegan Castle and woven a clan history as complex as any tartan, gathering some significant heirlooms and hosting several distinguished guests along the way.

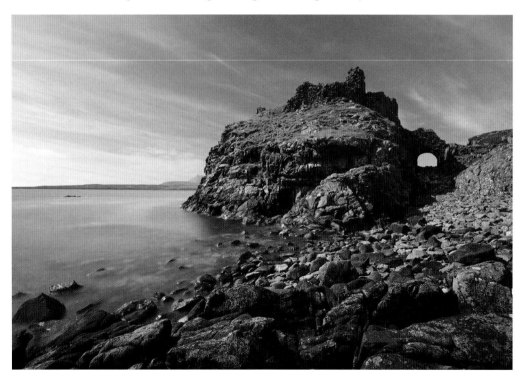

Remains of Dunscaith Castle – held at various times by the MacDonalds, the MacLeods, and the MacAskills

Of these heirlooms, the most revered is the Fairy Flag. All manner of supernatural powers are attributed to this now tattered fragment of silk, including the ability to cure cattle of disease, lure herring into Loch Dunvegan, and, most importantly, protect the clan from disaster. The flag is yellowy-brown and embroidered with small red 'elf spots'. In the 1100s, it may have flown high as the sacred 'Land Ravager' banner of Norwegian King Harold Hardrada.

Notable guests at Dunvegan have included the English writer Samuel Johnson and his biographer, James Boswell, who stayed during their tour of the Highlands in 1773. King James V is also said to have visited to test the bluster of Rory Mor, the 15th chief of the clan. Rory had previously boasted that he enjoyed finer banquets at Dunvegan than at the Royal Court in Edinburgh. Keen to make good on his claim, the chief took King James up onto Healaval Mhor, one of two flat-topped mountains on Duirinish. There, the king was served a lavish banquet under the stars, lit by the torches of hundreds of MacLeod clansmen. Today, those mountains are known as MacLeod's Tables.

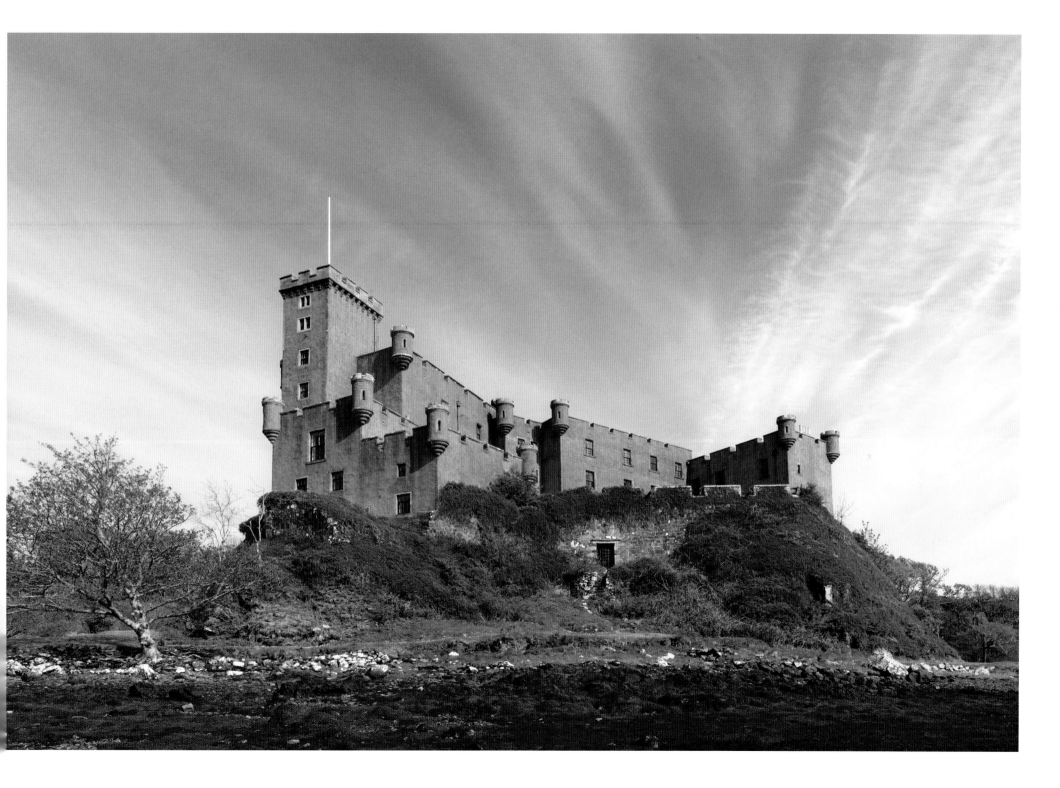

Clan MacDonald

The southern peninsula of Sleat – meaning 'smooth' in Norse – is notably distinct from the rest of Skye. The woodlands and pastoral landscape are softer in character and, while the rest of the island is dominated by the MacLeods, Sleat is MacDonald country.

The MacDonalds trace their origins back to the legendary half Norse, half Celtic warrior Somerled. During the 1100s, Somerled wrestled control of Scotland's west coast from the Vikings, and his descendants became the Lords of the Isles. The clan first began to assert itself on Skye in the 1400s. At various times, its people occupied castles at Dunscaith and Knock in Sleat, and Duntulm on the northern coast of Trotternish. All of these castles are now in ruins.

The MacDonalds of Sleat are one of the clan's leading branches, and hold the right to the title Lord MacDonald. Armadale Castle and its surrounding 20,000 acres represent the last remaining property belonging to the clan. Armadale was once the grand main residence of the MacDonalds of Sleat, but it was abandoned to the elements in 1925. Today, it is mostly a picturesque ruin set in impressive gardens.

The Sleat branch of the clan is often referred to as Clan Ùisdein, after its founder Hugh – Ùisdein being the Gaelic form of the name. Clan Ùisdein's most renowned daughter is undoubtedly Flora MacDonald. She is famous for her part in the legendary escape of Bonnie Prince Charlie (Charles Edward Stuart) after the 1746 defeat of the Jacobites at Culloden. The prince, disguised as Flora's handmaiden, was smuggled to Skye from Benbecula in the Outer Hebrides. There, he was kept safe until he could be transported to the mainland and escape to France. For her troubles, Flora spent a short time imprisoned in the Tower of London before being released in 1747. Widely respected for her honour and bravery, she was described by Samuel Johnson as 'a woman of soft features, gentle manners, kind soul and elegant presence'.

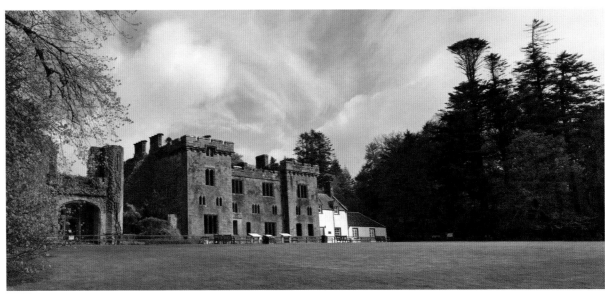

Flora MacDonald's grave, Kilmuir *Armadale Castle*

Right: Ruins of Duntulm Castle, Trotternish

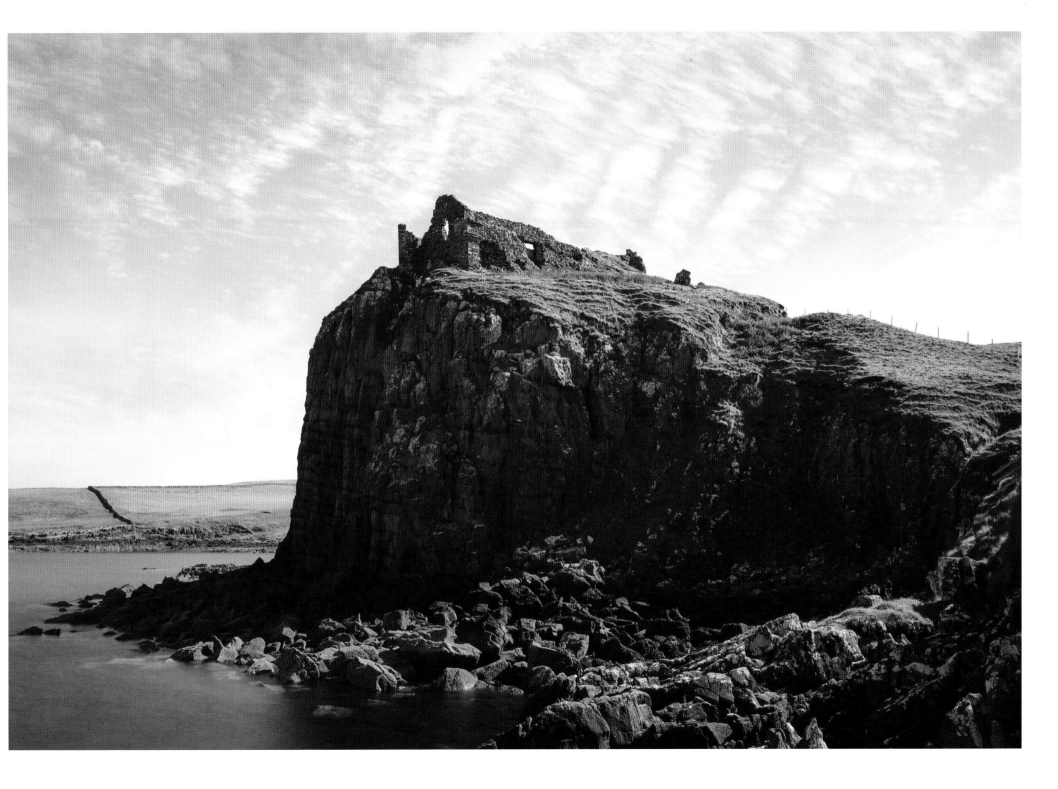

THE CLEARANCES

Scattered across Skye are the remains of many cleared settlements – a reminder of a time of grave injustice that can still arouse strong emotions. The roots of this notorious period can be traced back to the 1746 Battle of Culloden. In this battle British loyalist forces decisively defeated the Jacobites, who, led by Bonnie Prince Charlie, had sought to reinstate the Stuart dynasty to the British throne.

Only a small minority of clansmen participated in the rebellion, but the clan system and Gaelic culture as a whole suffered as a result. Clansmen were forbidden from wearing tartan or bearing arms. Clan chiefs, who had traditionally measured their power and prestige by the size of their armies, now looked to profit from their lands, rather than seek loyalty from their tenant soldiers. This fundamental change in their relationship with their tenant crofters (small-holding farmers), coupled with the growing demand for mutton and wool, paved the way for over a century of betrayal and persecution.

Crofting communities were vilified as backward and even racially inferior by lowlanders. They were forcibly and often brutally evicted from their homes and land. Their houses were usually torched, often with little or no notice. Many perished, cast out into the elements without regard for age or gender. Of those who survived, some were coerced into moving onto poor coastal land, or to growing cities such as Glasgow. Tens of thousands either chose, or were forced, to emigrate to the Americas and Antipodes.

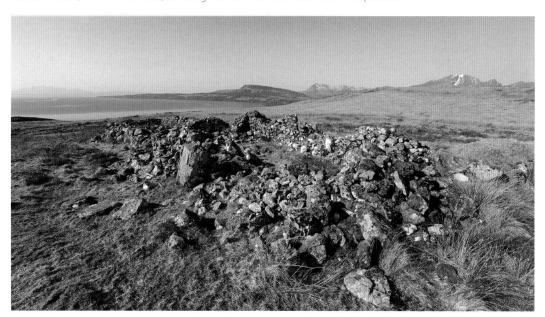

Remains of a dwelling at Suisnish – the tang of injustice still haunts this picturesque location

The people of Skye played a pivotal role in ending these abuses. In 1882, crofters and their families in the Braes district south of Portree resisted the eviction of their grazing stock by a 50-strong constabulary drafted in from Glasgow. In the aftermath of this encounter, which became known as the Battle of the Braes, a number of locals were prosecuted. However, the conflict brought the crofters' maltreatment to the attention of a sympathetic national press. This eventually led to the passing of the 1886 Crofters' Holdings Act, which gave the farmers greater security of tenure.

Claims that the Battle of the Braes was the last battle to be fought on British soil are perhaps an exaggeration, but this small uprising did prove to be a significant turning point for crofters throughout the Highlands.

Right: Ruins, Suisnish

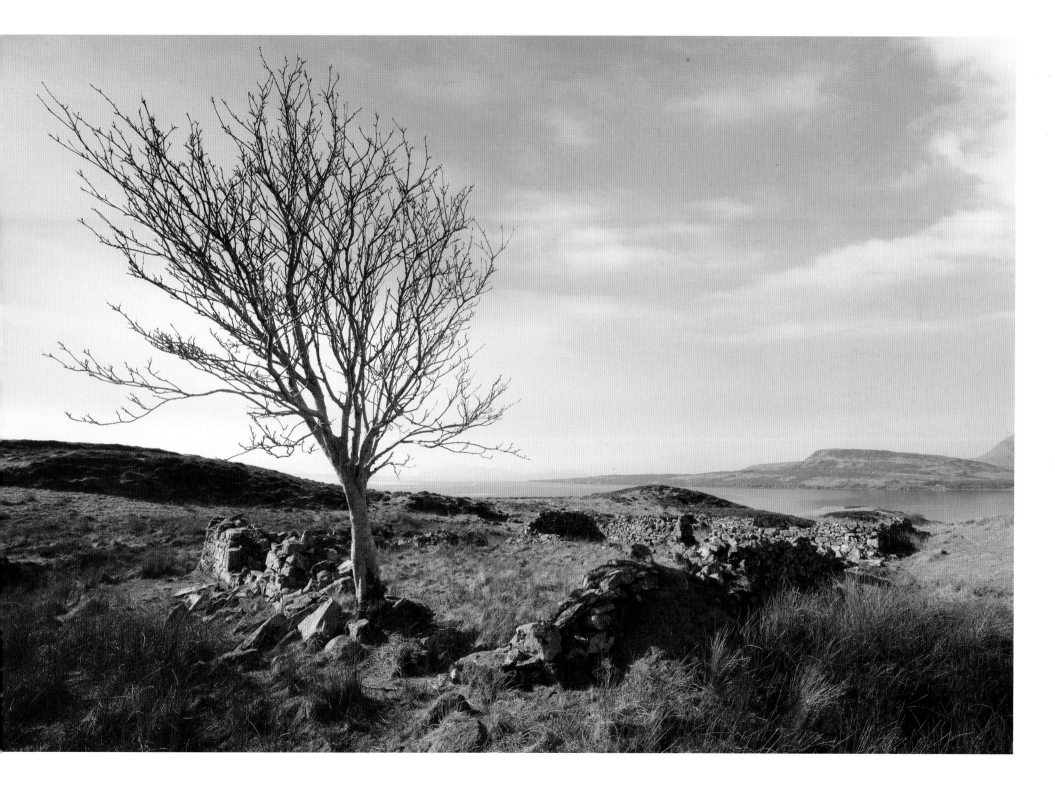

FORSAKEN KIRKS

Christianity is thought to have first come to Skye by way of Ireland in the 500s. The many ruined kirks (churches) and cemeteries dotted across the landscape are monuments to its extensive role in the island's history. Now being reclaimed by nature, these ruins are poignant reminders of our own mortality. Headstones list haphazardly, adrift on a sea of unkempt turf. Moss and lichens invade the formal geometry of the masonry. The centuries are progressively erasing the once sharply chiselled epitaphs of rich and poor, old and young.

In Kilmuir cemetery, the gravestone of the once celebrated piper Charles MacArthur lies with the epitaph unfinished. It is said that when the piper's son – who had commissioned the stone – drowned while crossing the Minch, the mason believed there was little prospect of being paid and simply abandoned his work mid-sentence.

Also in Kilmuir cemetery is the grave of Angus of the Wind, so called because of his proclivity for going to sea in any weather. His impressive slab, depicting a knight in armour, is rumoured to have been stolen from an ancient Scottish king's grave on Iona and hauled up to the cemetery by Angus himself. This colourful tale bears little scrutiny, however. The style of the effigy is entirely in keeping with that of grave markers for clan chiefs of the time.

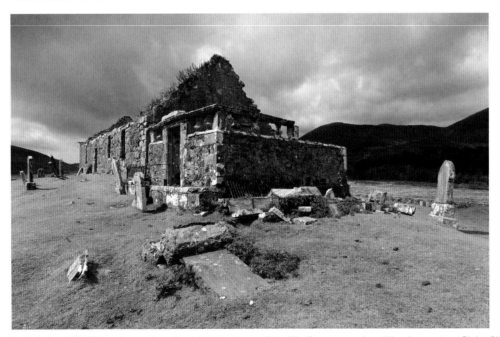
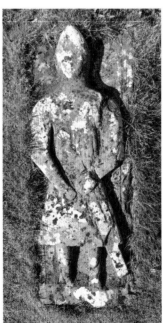
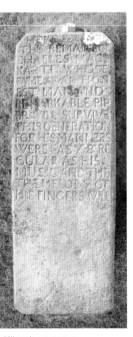

Left: Ruins of Cill Chriosd, near Broadford; Middle: Angus of the Wind's grave marker, Kilmuir cemetery; Right: Charles MacArthur's unfinished inscription, Kilmuir cemetery

Right: Weathered monument, Dunvegan church cemetery

THE BRIGHT LIGHTS

Portree, with a population of around 2,500, is Skye's largest settlement and main cultural and commercial centre. The town is located just south-east of the Trotternish peninsula, nestled around a scenic natural harbour. It is known for the brightly painted buildings on the harbour's south-west side, but the bulk of the town's centre sits on the high ground surrounding the bay.

The town's Gaelic name, Port Rìgh, translates as 'King's Port', alluding to a visit by King James V of Scotland in 1540. The king had come to the Western Isles to assert the rule of law and the Crown's dominion over the rebellious Hebrideans. For nearly 50 years the islands had been in turmoil, marred by power struggles after the forfeiture of the Lordship of the Isles in 1493. The king's show of force in 1540 successfully brought the region to order, for a short while at least.

Broadford is Skye's second largest settlement and the main service centre for the south of the island. Spread around the shores of a wide bay, it lies in the shadow of the Red Cuillin. The village was founded in the 1700s as a cattle-trading market, but is better known as the home of the liqueur Drambuie. The story goes that the recipe was gifted to Captain John MacKinnon for assisting the fleeing Bonnie Prince Charlie after the Battle of Culloden in 1746. For over a century Drambuie was produced only for the MacKinnons' personal consumption, before eventually being offered to patrons of what is now the Broadford Hotel. Today, the prince's personal tipple has grown into an internationally recognised brand.

Across the island is a scattering of villages and coastal settlements. Uig, on Trotternish's west coast, is principally known as the port for ferries to the Outer Hebrides. Overlooking Uig's harbour is the incongruous Captain Fraser's Folly, also known as the Uig Tower. This ostentatious display of wealth was built in the Norman style by Major William Fraser – an arrant Highland clearer – on the site where his tenants paid their rent. It is still associated with this dark chapter in the Highlands' past.

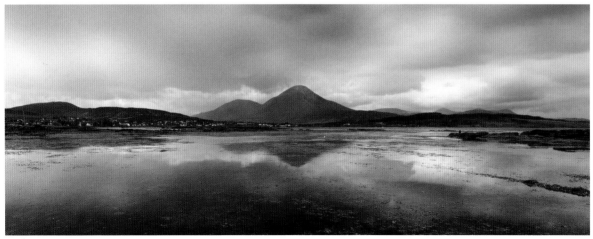

Broadford Bay

Captain Fraser's Folly, Uig

Right: Portree Harbour

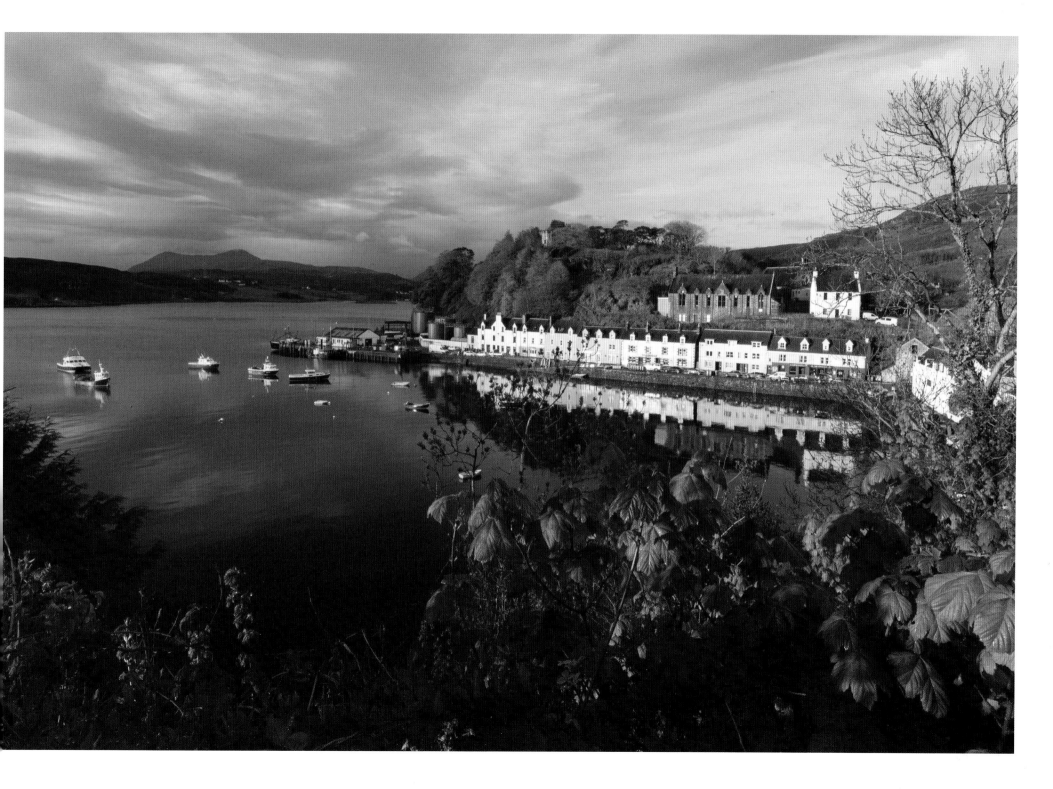

GROWING WILD

Skye's lowlands are dominated by the rich greens and golds of its abundant moors and grasslands. Closer inspection reveals a rainbow of wild flowers and delicate mosses, lichens and fungi – microworlds that thrive in the clean air carried in from the Atlantic.

After the glaciers retreated at the end of the last ice age, around 11,500 years ago, woodlands colonised much of the island – first of birch; later of hazel, pine and oak. Then, around 5,000 years ago, the climate became cooler and wetter, and the forests began to thin. Agriculture also had an impact, as did the island's large deer and sheep populations, and today only small pockets of ancient woodland remain. Heather moors and blanket bog (peatlands) have largely replaced the woods. It may come as a surprise that the blanket bog is in fact a globally rare environment. It will be less of a revelation to Scottish Highlanders that their land is home to much of the world's blanket bog resource.

Because Skye's alpine and temperate environments are so diverse, and its geology is so complex, each of the island's main peninsulas boasts its own flora. In the north-east, the basalt of Trotternish supports alpine and Arctic plants such as mossy cyphal and pearlwort. Alpine rock-cress ekes out an unlikely existence on the otherwise bare heights of the Black Cuillin; it is found nowhere else in the British Isles. During

Mosses thrive on Skye

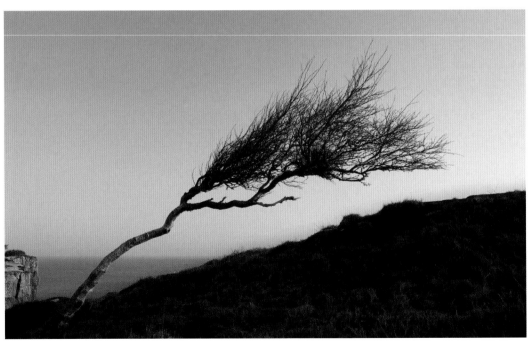

Exposed to the prevailing westerly winds, a silver birch leans into the hillside

Right: Allt Na Dunaiche
Overleaf: Trotternish Ridge and moorland

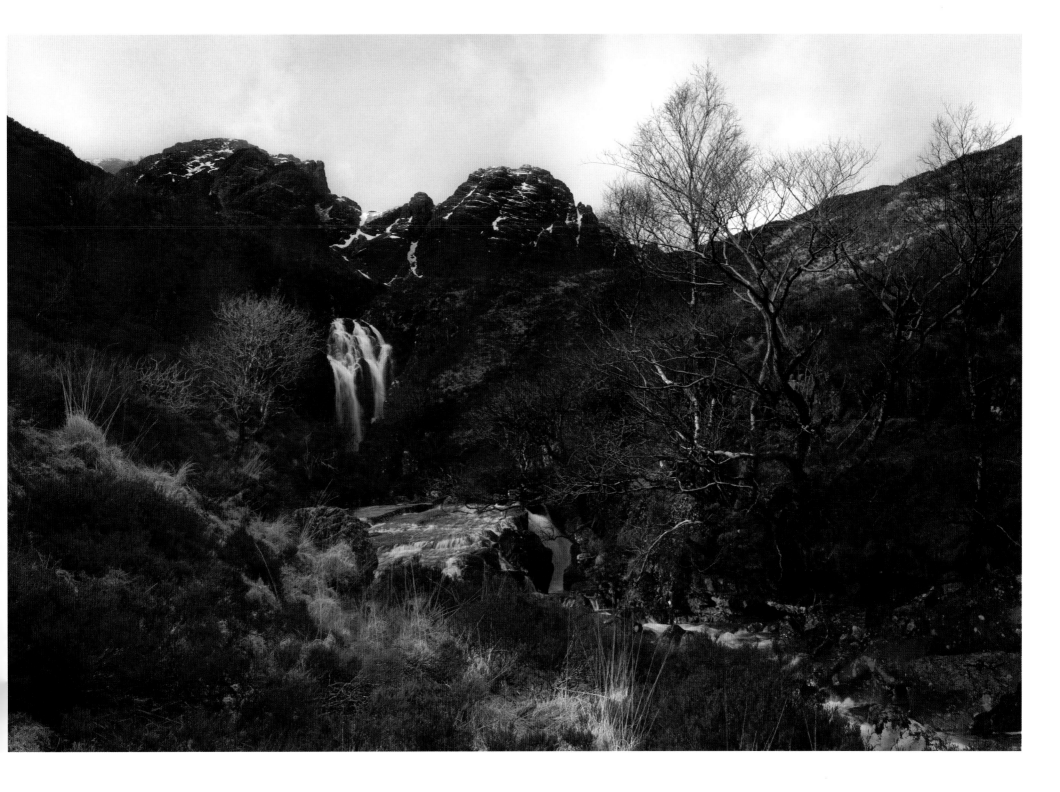

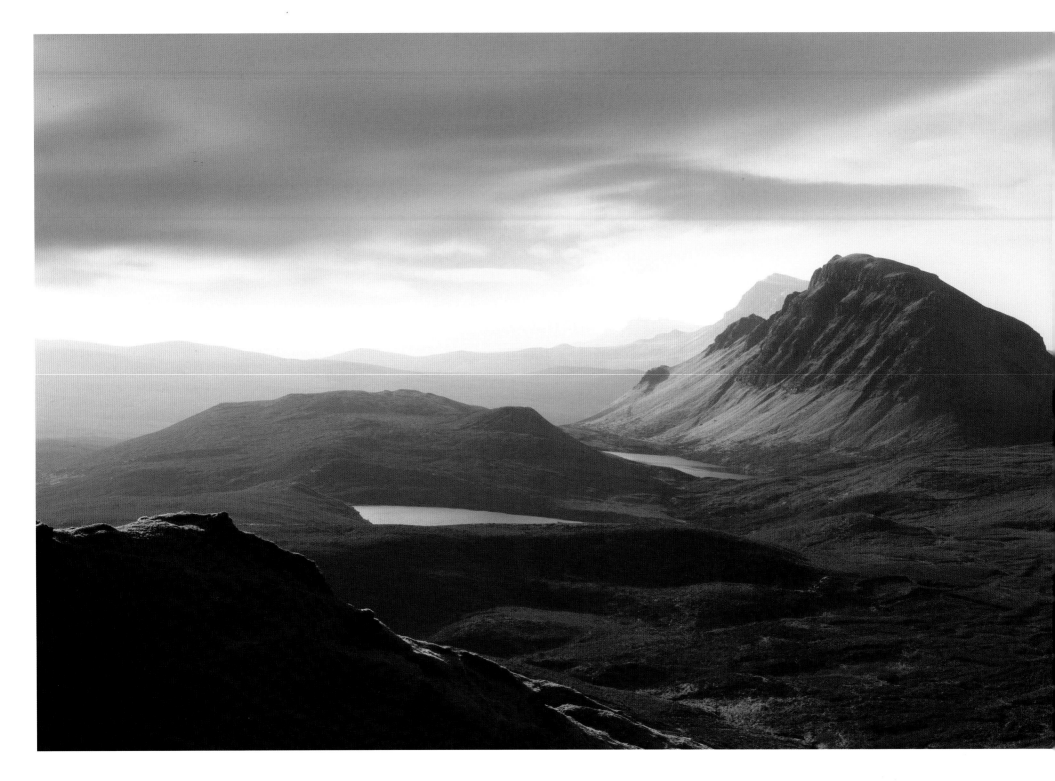

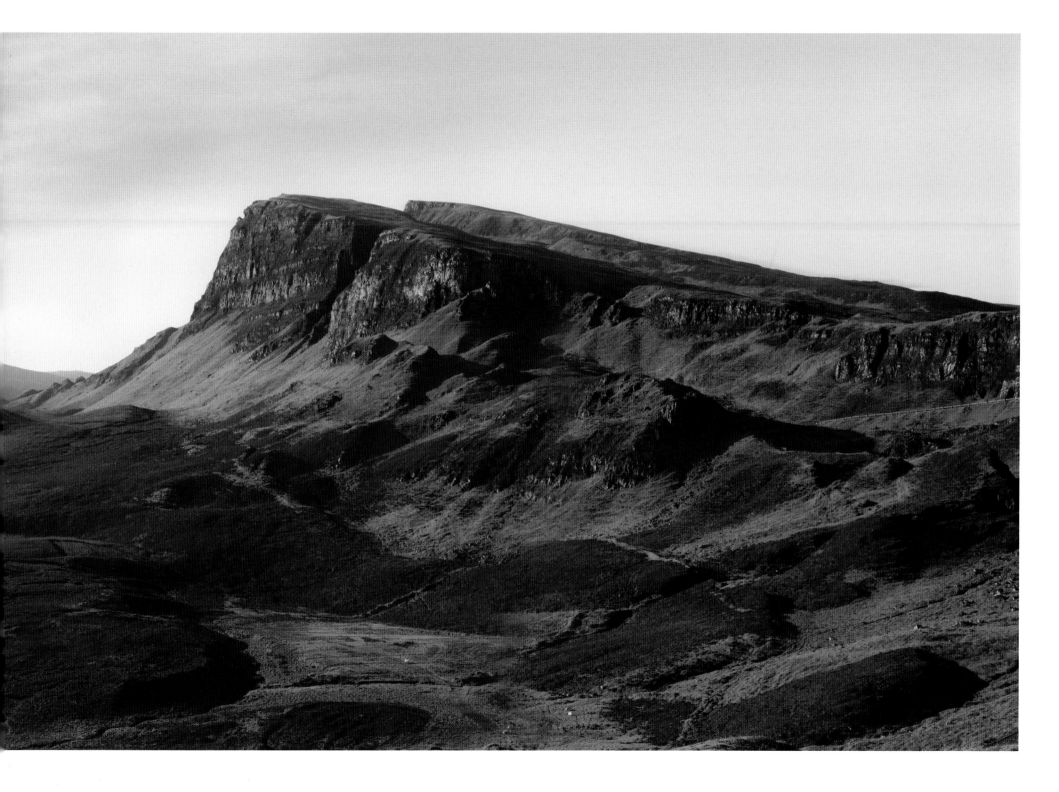

spring and summer, wild flowers such as yellow primrose flourish, and bluebells transform entire woodland floors into carpets of colour. Numerous mosses and lichens thrive in the clean air, painting the rocks and festooning the trees.

Farming the Fringes

Cultivating the marginal tracts of Scotland's hillsides has always been a challenge. Before fixed-tenancy crofting, a system known as 'runrig' was used to equitably share the best land. A 'rig' is a line of ploughed land, and the run is the uncultivated space between these strips. Allotments of runrigs were rotated annually among tenants. Today, these strips can still be seen on slopes around the country, but 'Runrig' is now more familiar as the name of a popular Celtic rock band from Skye.

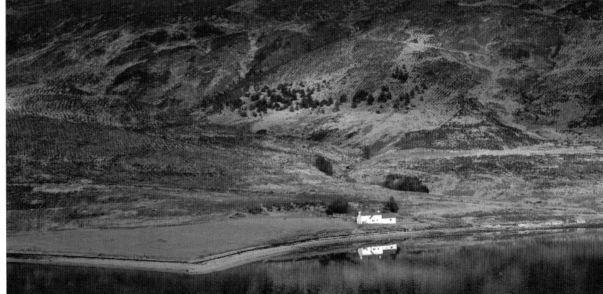

Left: Springtime bluebell; Right: Viewed from Ard Dorch, runrigs etch a Scalpay hillside; Top: Lichen colonies cover a Sleat boulder

Right: Ancient forest, Coille Dalavil, Sleat

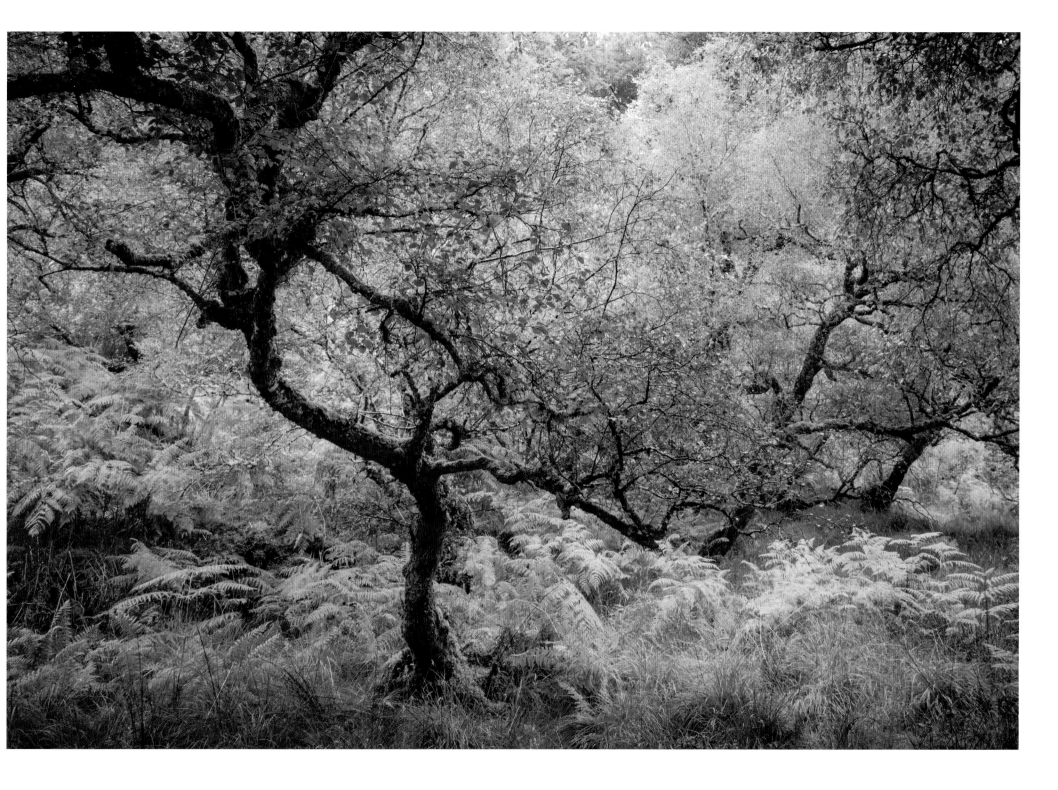

SPAR CAVE

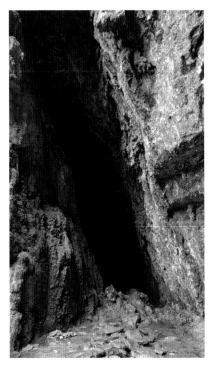

Spar Cave is another striking by-product of Skye's complex geology. Tucked away below Glasnakille at the south-eastern end of the Strathaird peninsula, the cave is part of a narrow band of limestone and marble that stretches from Skye all the way up to the north Sutherland coast. Exploring the cave's dank recesses feels like passing through a portal into an alien world. Access is possible for only one hour each side of low tide, via a narrow sea inlet with towering limestone walls – likened to 'some deep cathedral aisle' by pioneering geologist John MacCulloch.

At the top of the inlet are the remains of a stone wall built in the 1800s by the landowner Alexander MacAllister to deter unguided visitors. The wall, which had only limited success, met its end when a passing gunboat used it for target practice. Beyond it, the cave entrance – shaped like a melted Gothic cathedral arch – beckons you inside.

On entering the cave, the daylight falls away sharply as you reach the bottom of a steep, 50 metre tumble of flowstone – sheets of calcite that have built up to resemble a frozen waterfall. Despite looking treacherously slippery, the flowstone does in fact offer excellent grip. At the top, the ground plateaus before falling away to a pool of clear water, immortalised in Sir Walter Scott's poem 'The Lord of the Isles':

> *And mermaid's alabaster grot,*
> *Who bathes her limbs in sunless well,*
> *Deep in Strathaird's enchanted cell ...*

The grotto – once a popular Victorian attraction – has suffered smoke damage, and the large stalactites that hung from its ceiling have been pilfered. However, it is still an extraordinary, and evolving, spectacle. A continual flow of calcium-laden water oozes from the rock, depositing its crystalline cargo as it goes, and building upon the many strange organic formations, known as speleothems.

Spar is also known as the Nursling Cave, or Slochd Altrimen in Gaelic, which relates to a tale of forbidden love from the 800s. A young chief from a rival clan was shipwrecked with his dog in a storm. Dounhuila, the daughter of the local chief, discovered his identity but kept it secret and nurtured the young man back to health. Romance blossomed and, in due course, Dounhuila gave birth. Knowing that they were in mortal danger should her lover's allegiances be discovered, she arranged his escape and hid the baby in the cave. There, it was cared for by a loyal servant and guarded by the young chief's ever-faithful dog, with Dounhuila making covert trips to nurse the child. Against the odds, the story ended happily, with the feuding clans reconciling and the couple marrying.

Top: Entrance to Spar Cave
Bottom: Sea inlet leading to Spar Cave

Right: Inside Spar Cave

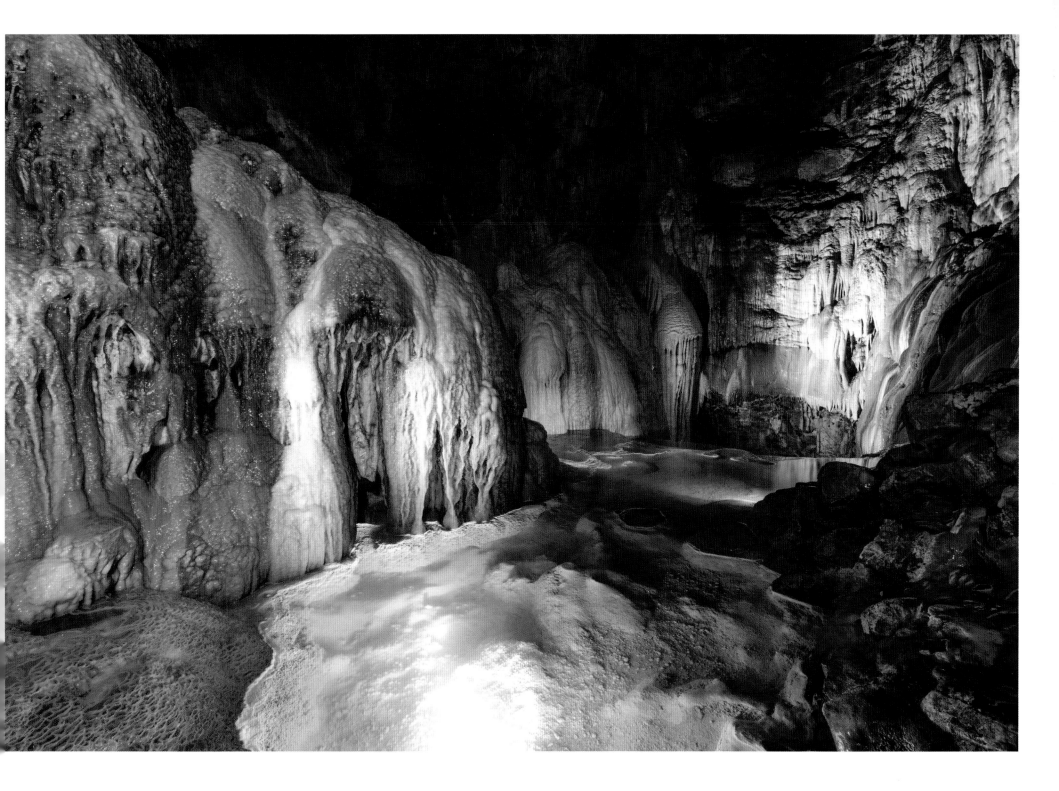

FAIRY LEGEND

The perception of fairies as gentle, winged sprites is relatively recent and owes much to the whimsy of the Victorian imagination. Fairies in Celtic mythology, though often described as 'wee folk', can assume many different forms, and an encounter can be either helpful or perilous to us mere mortals. Anyone who has tested their endurance against the elements on Skye will readily understand how the island's wild and lonely places have become imbued with supernatural lore. Even on a relatively calm day, the murmurings of water and whisperings of the wind give the impression of a land alive and somehow sentient. The rugged and mysterious nature of the highlands, both life-giving and demanding of respect, is aptly reflected in the mercurial character of Celtic fairies.

A number of places on the island are associated with fairies, the most celebrated being the Fairy Glen near Uig, the Fairy Pools in Glen Brittle, and the Fairy Bridge at the southern end of the Waternish peninsula. The Fairy Glen looks like a miniaturised landscape, with its collection of conical hills clustered around a lochan. Standing above it is an oblong stump of rock known as Castle Ewan, and behind that is a tiny glen – the perfect place for fairies to gather away from prying human eyes.

The Fairy Pools in Glen Brittle are also relatively small – a suitable haunt for 'wee folk'. Here, a series of modest waterfalls cascade down from the Black Cuillin. At their foot you can take a bracing dip in the clear, cold waters of the Fairy Pools – reputed to have healing powers.

Fairy Bridge, Waternish

The famous Fairy Flag at Dunvegan is said to have come into the possession of the MacLeods at the otherwise unassuming Fairy Bridge. Legend tells of how a clan chief married a fairy, who bore him a son. After a while the fairy mother felt compelled to return to her own kind, greatly distressing the smitten chief. He followed her as far as the Fairy Bridge, where, despite his protests, she bade both him and her son a final farewell. As she ascended into the sky, she let fall a piece of silk and said, 'Keep this flag, and unfurl it to the wind whenever a crisis hits you. It will save you and yours twice, but woe unto you if you unfurl it a third time.'

Many other myths and superstitions are associated with Skye's treacherous seas. The Blue Men of the Minch lure sailors towards calamity, seagulls are the souls of men lost to the ocean, and 'to whistle up the wind' is to invite a gale and possible shipwreck. Inhabiting the depths are strange beasts such as skelpies, who live as seals in water but can shed their skins to live as humans on land. Kelpies are shape-shifting water horses that dwell in the dark waters of the lochs. They, too, can assume human form – as handsome men or seductive young women with the power to draw the unwary to their deaths. The theme common to many of these myths is that the water can be seductive but dangerous – just like an alluring stranger.

Right: Fairy Glen, Trotternish
Overleaf: Fairy Pools, Glen Brittle

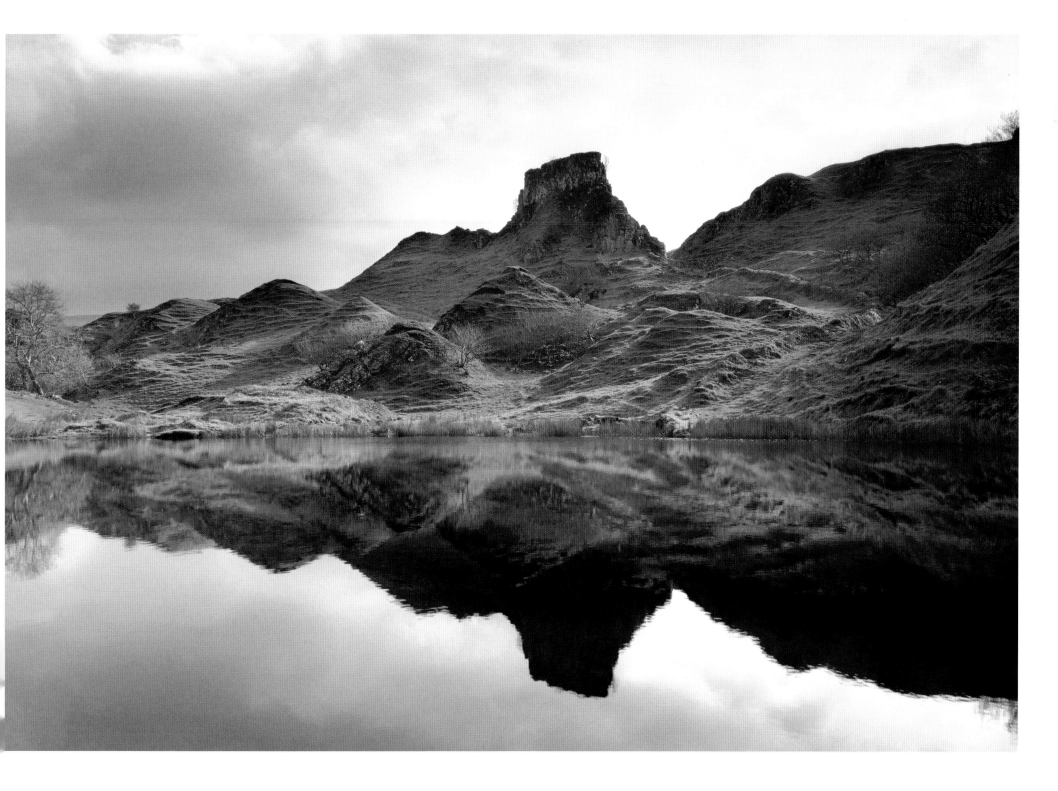

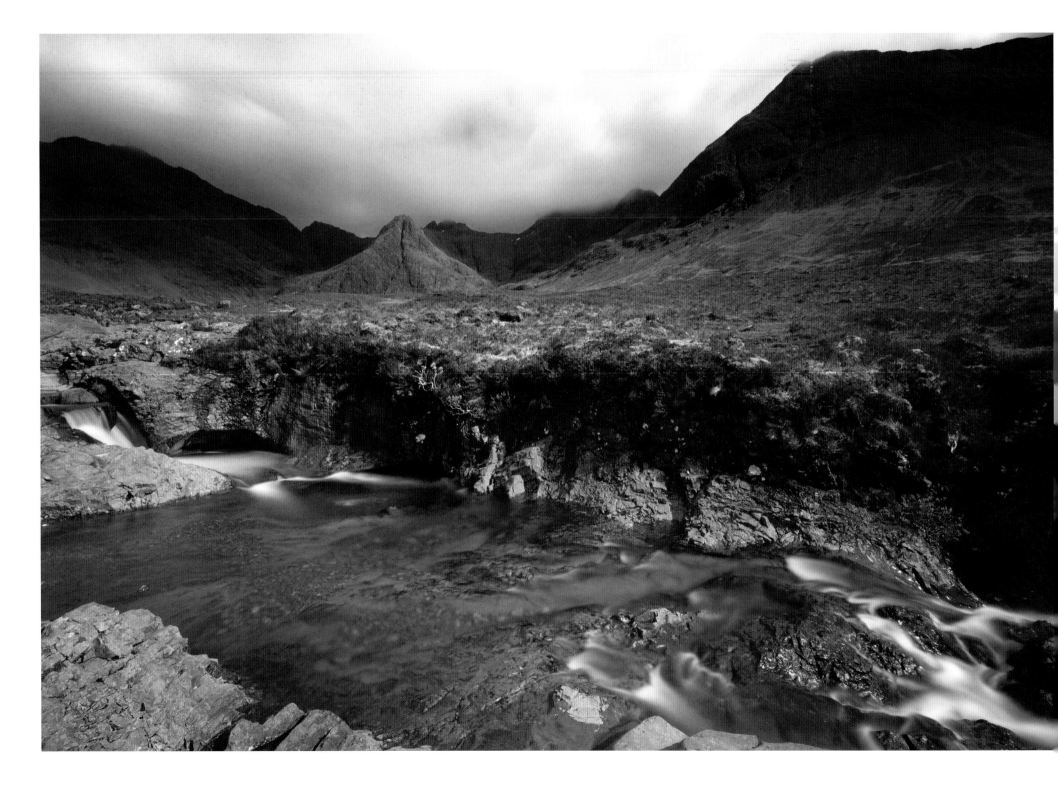